Buses of Clydeside Scottish & Clydeside 2000

David Devoy

AMBERLEY

First published 2014

Amberley Publishing
The Hill, Stroud
Gloucestershire, GL5 4EP

www.amberley-books.com

Copyright © David Devoy, 2014

The right of David Devoy to be identified as
the Author of this work has been asserted in
accordance with the Copyrights, Designs and
Patents Act 1988.

ISBN 978 1 4456 3970 3 (print)
ISBN 978 1 4456 3982 6 (ebook)

British Library Cataloguing in Publication Data.
A catalogue record for this book is available from
the British Library.

Typesetting by Amberley Publishing.
Printed in the UK.

Introduction

In 1961 the Scottish Bus Group decided to split the huge bus fleet of W. Alexander & Sons into three more manageable units. So Alexander Fife, Northern and Midland were formed. The Midland company absorbed its subsidiary David Lawson of Kirkintilloch. The Lawson company was then renamed as Clydeside Omnibuses Ltd in preparation for the proposed split of Western SMT. For whatever reason, this would not happen for a further twenty-four years.

In 1985, deregulation of local bus services was on the horizon and the Scottish Bus Group was enlarged from seven bus operating subsidiaries to eleven by splitting some companies. Western was one of those chosen, so Clydeside Scottish was set up in March 1985. 334 buses operating from depots in Greenock, Rothesay, Largs, Paisley, Johnstone, Inchinnan and Thornliebank passed to the newly formed company, which began trading on 17 June 1985. A withdrawn Western Seddon was repainted using various shades of red and yellow until it was decided to use Mason's bright red and lemon chrome as the new livery. A public launch was held in Glasgow's Buchanan bus station on 12 June. Orders outstanding for the new company would see twelve Dennis Dominators and nine Dennis Dorchester coaches delivered. As is well known, a huge fleet of rear entrance AEC Routemasters were placed in service with conductors. The route network was very unstable, with routes changing on a regular basis and an accounting error leading to a drastic cost-cutting exercise. This strengthened the company's main rival Strathclyde Buses, who was seen as a more stable operator that kept its core services and livery unchanged. It is fair to say that Clydeside probably suffered from more competition (often set up by ex-members of staff) than any other operator in the country.

With the privatisation of the Scottish Bus Group announced in 1988, it was decided to remerge the Clydeside and Western Companies under the latter's control. This happened in 1989 and Western immediately decided to withdraw the Routemaster fleet. This was seen as a ploy to weaken Clydeside and any chance of them mounting a successful buyout. Western began to reapply its own livery to the fleet. After much haggling, the two sides reached a compromise and it was agreed that Western management would buy the company and immediately sell the Clydeside portion on.

The former Clydeside staff linked up with Luton and District to finance the buyout. To do this, an off-the-shelf company Lycidas 186 applied for an operator's licence for 375 vehicles. Prior to this, all repaints in the former Clydeside area had been suspended and the fleet was looking rather scruffy. The main difference this time was that Rothesay depot was not included and Clydeside lost their half share in the Glasgow–Kilmarnock service. Western management had driven a hard bargain as they bought the complete company for £1 million and sold on the Clydeside operations for £1.25 million.

The independent Clydeside 2000 began trading from 14 October 1991 and adopted a more modern version of the familiar red and yellow livery. The opening fleet comprised of 307 buses. When major competitor Argyll Coaches of Greenock ceased trading, Clydeside purchased the assets, and Inverclyde Transport was bought out in May 1993. There was a proposal to set up a low cost subsidiary in Greenock under the title of Blue Bus, but it came to very little. In Paisley, Goldline Travel was purchased in October. A deal was reached with Strathclyde Buses that saw Clydeside retreat from Glasgow local services in exchange for an SBL withdrawal from Renfrewshire. It was said at the time that SBL was more afraid of Clydeside collapsing and a bigger player moving into the area. The company offered itself to Stagecoach, but they had bigger fish to catch at the time.

Minority shareholder Luton and District was taken over by British Bus, and that company obtained full control of Clydeside in November 1995. A rival bid from Rapsons was never put to the shareholders, as British Bus threatened to close the company down immediately if its proposals were not accepted. It was then announced that no investment would be forthcoming until the company made a profit. Fortunately, the traffic commissioners had different ideas and threatened a drastic cut in the amount of vehicles allowed on the operator's licence. A new MD was appointed and during his interview misread the fleetname as 'Clydeside Zoo', so the company simply became Clydeside Buses. British Bus tried to bully McGill's of Barrhead into selling out, but McGill's swore they never would (and didn't until Arriva days). Huge service cuts saw the fleet cut from 341 to 275 vehicles in December 1995.

British Bus sold out to the Cowie Group for £282 million in August 1996, and this was conditional on it being cleared by the OFT after a Serious Fraud Office investigation of British Bus chairman Dawson Williams. At last we had a company with some financial backing. Sixty-two vehicles were taken over from the Argyll Group in Inverclyde in July 1997, as was McGill's of Barrhead. The proposal was made to trade under the three different brands of GMS, McGill's and Clydeside Buses. New high-quality services were launched under the Flagship Renfrewshire brand and bargain basement services came under the F&L identity. This, along with lots of new low-floor buses, looked great for the future when, sadly, it was announced that the Cowie Group would go corporate under the Arriva brand and Clydeside was consigned to history from November 1997. The company seemed to lose interest when they realised their Scottish operations could not expand after failed bids for Midland Bluebird and Tayside. Managed decline became the order of the day, and after a couple of years I decided to try pastures new. Arriva management seemed to have no idea how to deal with the competition and the company became a distant outpost of Arriva North East until they sold out to McGill's of Greenock and quit Scotland for good.

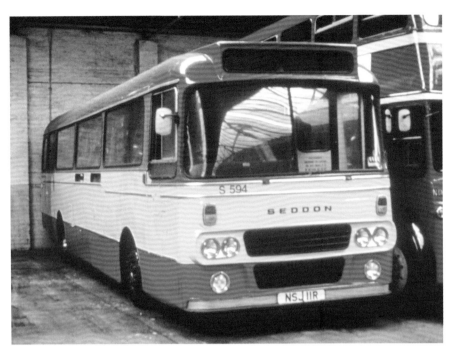

Prior to the formation of Clydeside, this withdrawn Western Seddon Pennine VII was used for livery experiments with various shades of red and yellow applied. It would actually join Clydeside in August 1985, numbered as G811.

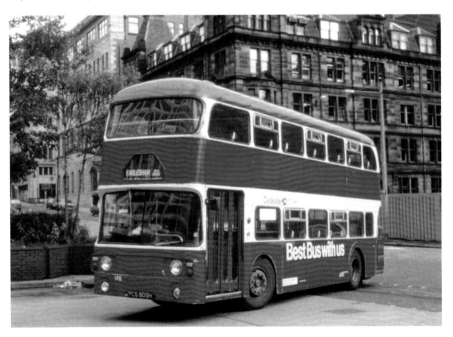

M8 PCS 809H was a Daimler Fleetline CRG6LX/Alexander D Type H75F new to Western in June 1970. It wouldn't last long enough to gain Clydeside livery, as it was used as an overturning exhibit at Greenock open day in 1986.

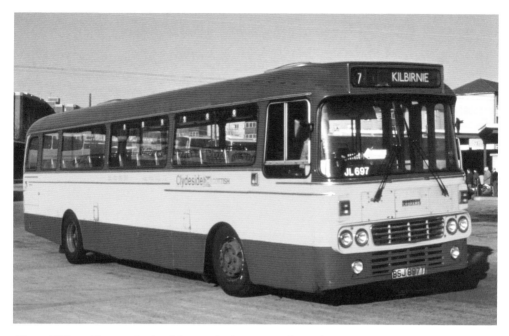

JL697 BSJ 897T was a Leyland Leopard PSU3E/4R/Alexander Y Type B53F purchased new by Western in June 1979. It was leaving Glasgow en route for Kilbirnie on a short working of the 17 service.

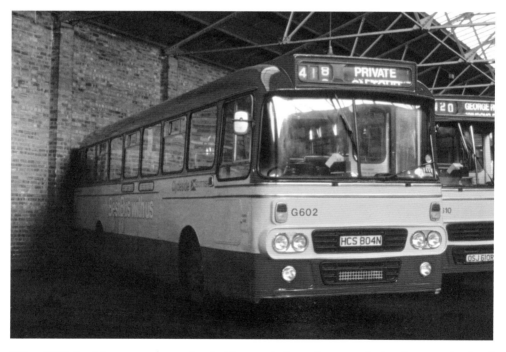

G602 HCS 804N was caught resting in Greenock depot between duties. It was a Leyland Leopard PSU3/3R/Alexander Y Type B53F, which would remain in the fleet until November 1987 when it passed to PVS (dealer) Carlton for scrap.

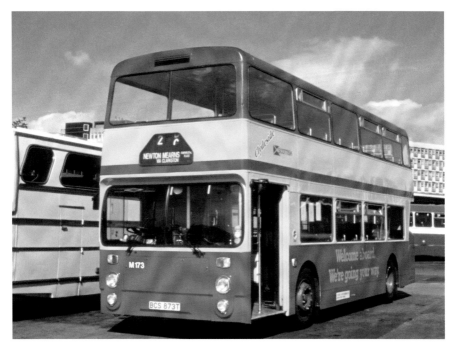

The red band on M173 BCS 873T was set around 6 inches higher than normal, as evident in this view taken in Glasgow's Buchanan bus station. This Leyland Fleetline FE30AGR/Northern Counties H75F was allocated to Thornliebank depot.

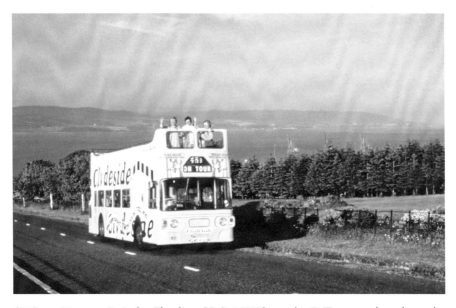

SMS 402H was a Daimler Fleetline CRG6LX/Alexander D Type purchased new by Alexander (Midland) as their MRF72 in February 1970 before transfer to Alexander (Northern) as NRF15 in June 1977. Clydeside acquired it in August 1985 and initially used it at Inchinnan depot. It was converted to open-top in 1986 and is seen here high above Greenock with the Clyde estuary behind it.

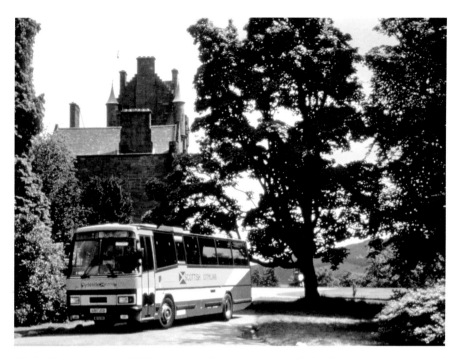

Clydeside I480 A180 UGB was one of sixteen acquired Gardner-powered Leyland Tigers that had been purchased new by Western in June 1984. They featured Plaxton Paramount 3200 C49F coachwork and all initially carried Scottish Citylink livery.

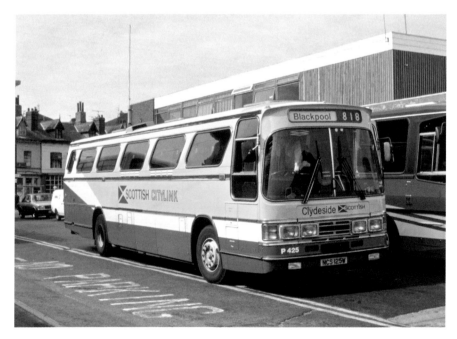

P425 NCS 125W had just arrived at Colluseum coach station in Blackpool and was a Volvo B10M-61/Duple Dominant III C46Ft. On disposal it passed to Midland-Bluebird as fleet number 201 before reaching Whitelaw's of Stonehouse.

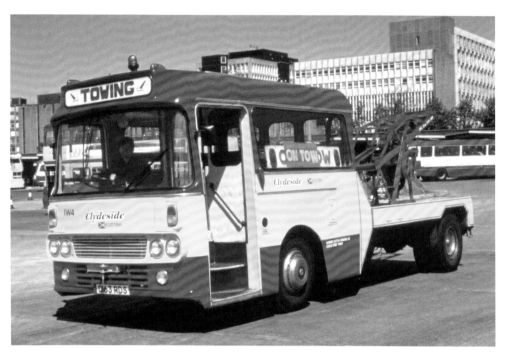

IW4 Q163 RDS was a Leyland Leopard/Alexander Y Type originally new to Western as CAG 456C in October 1965. It was converted to a tow-wagon in the ancillary fleet before passing to Clydeside in June 1985. It was rebuilt to this style complete with crane in January 1988 and looked superb.

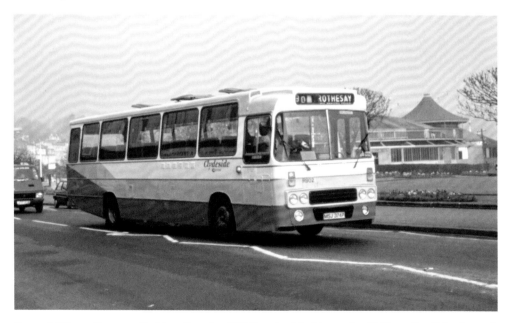

R902 MSJ 374P was a Seddon Pennine VII fitted with Alexander T Type C49F bodywork allocated to Rothesay depot. The dual purpose livery underwent many changes, but this was possibly the best version and probably influenced later livery designs.

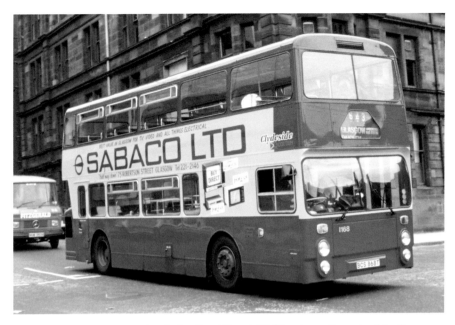

1168 BCS 868T was a Leyland Fleetline FE30AGR/Northern Counties H75F new to Western in May 1979. It was caught in Glasgow near Anderston bus station in this strange livery advertising an electrical retailer, but would have been more effective if the yellow had been carried around the front of the vehicle.

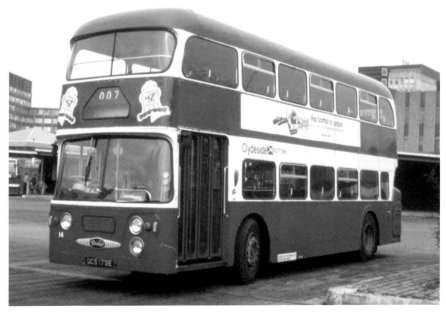

14 GCS 173E was another early model Daimler Fleetline/Alexander D Type H75F. It was new to Western SMT in February 1967 and joined the Clydeside fleet in September 1985 to combat a shortage of double-deckers. It was never repainted and lasted until April 1987 when it was sold to North (dealer) of Sherburn.

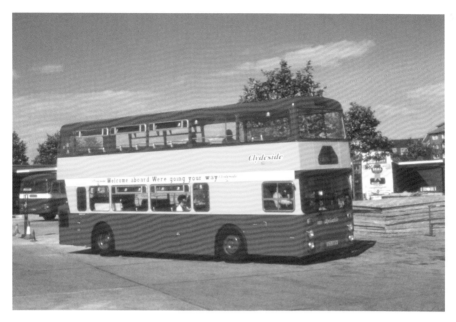

I181 ECS 181V was a Leyland Fleetline that once again predicted later trends by the use of white in the livery. One double-decker and one single-decker received this version, and I must admit I really liked it. The bus was allocated to Inchinnan depot and was photographed in Buchanan bus station in Glasgow.

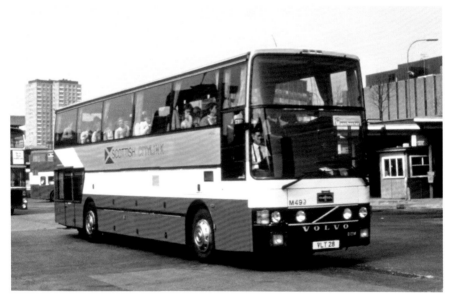

M499 VLT 28 (A853 TDS) was a Volvo B10M-61/Van Hool Astral CH56Ft purchased new by Harris of Armadale in 1984. It quickly passed to Newton's of Dingwall in 1985 and was included in the purchase of that business by the Scottish Bus Group in late 1985. It was transferred to Clydeside for use on Rapide services from Glasgow to Manchester. It returned to Highland Scottish when the route was extended to Inverness and became A199 WUS, with Clydeside retaining the cherished plate.

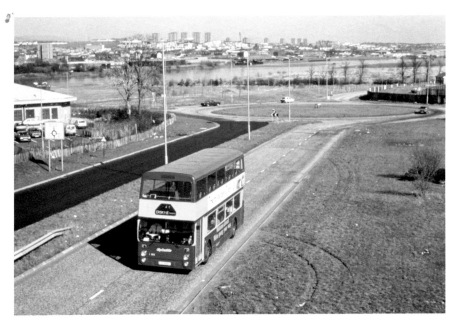

I180 ECS 880V. This Northern Counties-bodied Leyland Fleetline is seen in Erskine New Town near Bridgewater shopping centre, with the River Clyde in the background. Erskine is generally associated with the suspension bridge towering high over the western limit of the town, which is the furthest west crossing point on the River Clyde.

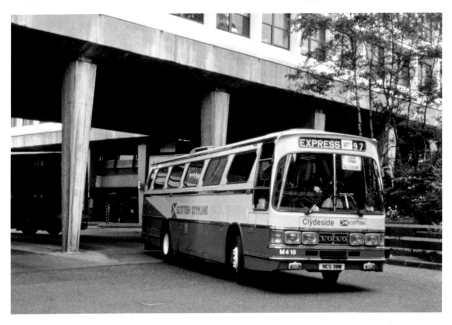

M418 NCS 118W was a Volvo B10M-61/Duple Dominant III C46FT purchased new by Western for use on the Scotland–London services. It was working on a Glasgow–Largs express service as it prepared to leave Anderston bus station. These fine looking coaches were not really suitable for local work as they had manual gearboxes resulting in a short clutch life.

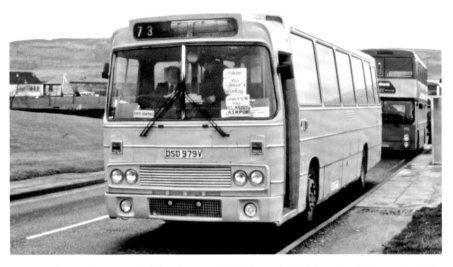

M979 DSD 979V was a Seddon Pennine VII/Alexander T Type C49F. It received this all-over yellow livery when it was sent on loan to Northern Scottish at the end of 1988. On its return, it was pressed into service at Inchinnan depot and is loading at Erskine Bargarran with a multitude of paper destination stickers.

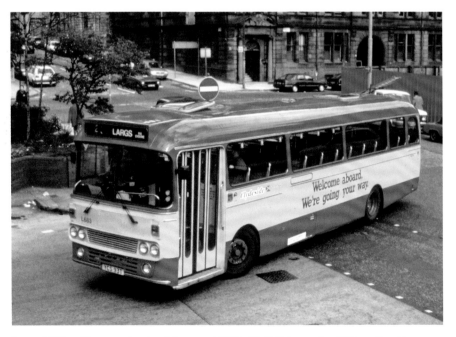

L683 YCS 93T was a Leyland Leopard PSU3E/4R/Alexander Y Type B53F new to Western as their JL2 804 in October 1978. It was allocated to Largs depot and had just arrived in Glasgow's Anderston bus station and featured the 'welcome aboard' logos and red block fleetname.

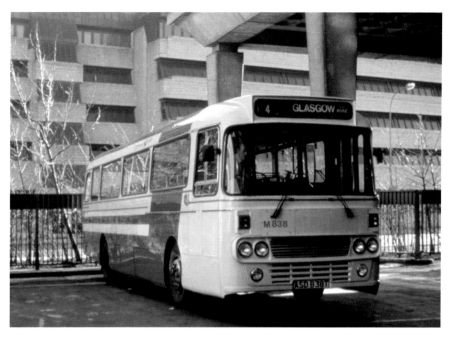

M838 ASD 838T was a Seddon Pennine VII/Alexander Y Type B53F. This experimental livery was applied in conjunction with Scottish Bus Group plans for all subsidiaries' buses in the Glasgow area to have yellow front ends, but thankfully it was not implemented.

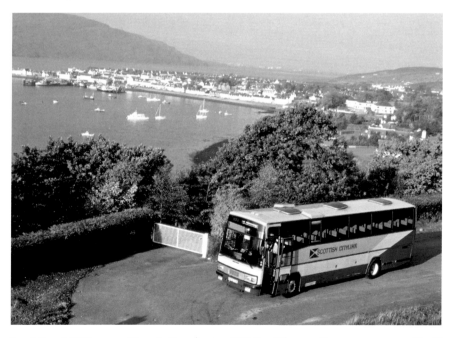

I406 B406 OSB was a Dennis Dorchester SDA810/Plaxton Paramount 3500 C55F on a tour of the Highlands and Islands. It will spend the night here in Ullapool before catching the Stornoway ferry tomorrow morning.

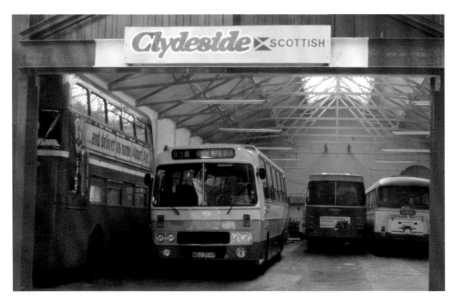

Western's outpost on the Isle of Bute was transferred to Clydeside Scottish control in June 1985 and a peek inside offers a fascinating glimpse of the fleet, with a stored Routemaster and several Seddon Pennine VIIs. Note the cutaway front panels on MSJ 374P designed to increase clearance when negotiating car ferries. The building was the original used to operate horse trams from 1882, but modernised in 1902 when the system was electrified by the BET Group. The trams finished in 1936 and were replaced by the buses of the Rothesay Tramways Company, which was absorbed by Western SMT in 1949.

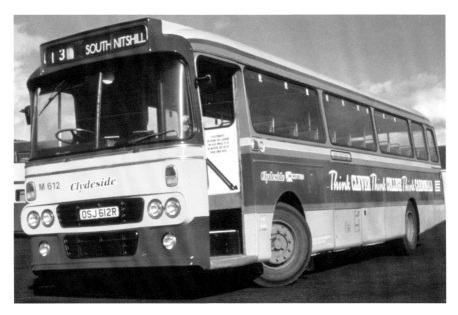

M612 OSJ 612R was a Leyland Leopard PSU3C/3R/Alexander Y Type B53F seen in Thornliebank depot while carrying an advert for Cardonald College. The narrow entrance doors were not ideal for city services but people's expectations were perhaps lower then.

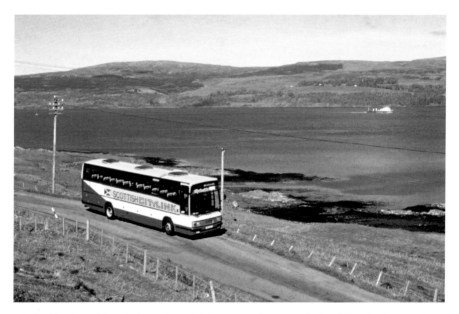

Clydeside Scottish tried to diversify into coach tours, helped by the late Robert Grieves, who was very enthusiastic. It spent many nights putting on presentations for church groups, community events and anything else where he could get an audience. This is a tour that he organised to the Isle of Bute in the Firth of Clyde, and we see 407 CLT (B407 OSB) following the coast road, while in the background there is a ferry of CalMac heading back to Wemyss Bay Pier. The coach was a Dennis Dorchester/ Plaxton Paramount 3500 C55F.

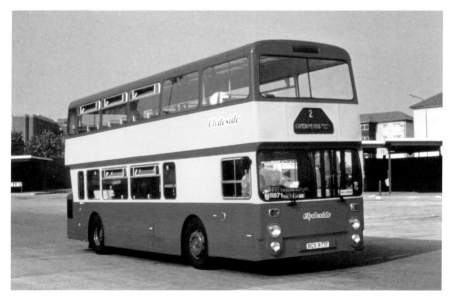

MR871 BCS 871T was a Leyland Fleetline FE30AGR/Northern Counties H75F working on service 2 bound for Eaglesham Village, which is about 10 miles south of Glasgow and is distinctive in being built around a large triangular green. It was designated Scotland's first outstanding conservation area in 1960.

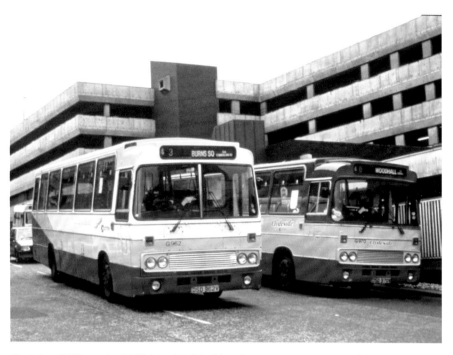

G962/70 DSD 962/70V. This pair of Seddon Pennine VIIs were caught in Greenock's Kilblain Street and demonstrate the different liveries applied. DSD 970V was unique in being reseated to B53F in March 1988.

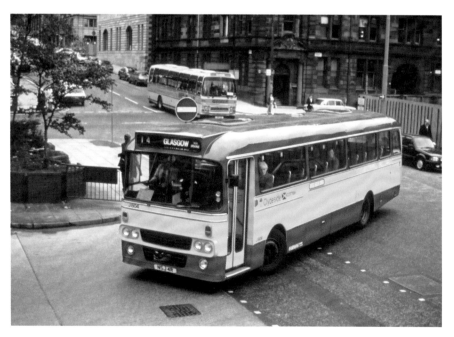

J804 NSJ4R was a Seddon Pennine VII/Alexander Y Type B53F purchased new by Western in August 1976. It was acquired by Clydeside in July 1985 and was approaching Anderston bus station in Glasgow with a Graham's of Paisley coach behind it.

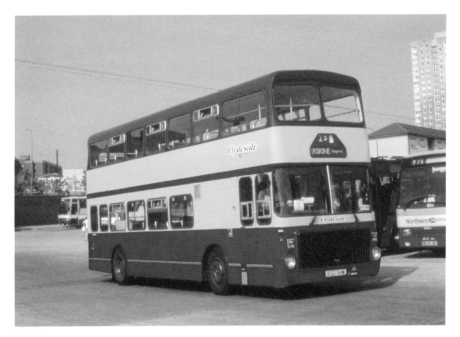

J94 KSD 94W was a Volvo Ailsa B55-10/Alexander AV Type H79F new to Western in October 1980. It was leaving Glasgow while bound for Erskine. It would later pass to Black Prince of Morley for further service.

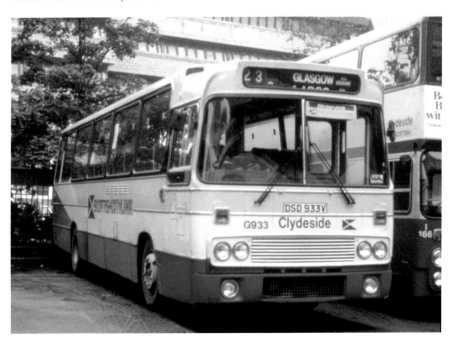

G933 DSD 933V was a Seddon Pennine VII/Alexander T Type C45F purchased new by Western in September 1979. It passed to Clydeside and was used in Scottish Citylink livery, but was laying over in Anderston bus station while operating on the Glasgow–Erskine service 23.

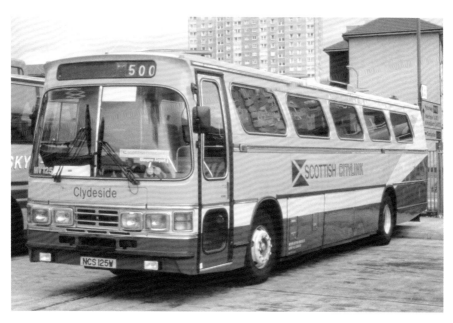

MV125 NCS 125W was a Volvo B10M-61/Duple Dominant III C46Ft seen laying over in Glasgow while working on the Scottish Citylink service that linked Edinburgh to Glasgow/Glasgow Airport.

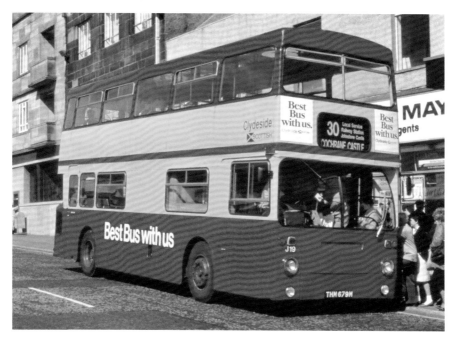

J19 THM 679M. This ex London Transport Daimler Fleetline/MCW was one of thirty-two purchased by Western. Fifteen of these passed to Clydeside on its formation and performed well mainly on the busy Glasgow–Johnstone services. Ironically, after London's dissatisfaction with these buses, fourteen of them were reacquired for their Bexleybus operations in 1987. J19 was seen in Johnstone town centre.

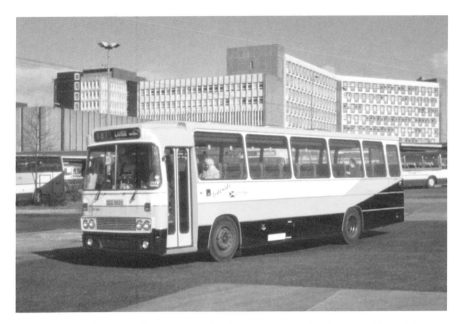

J969 DSD 969V was a Seddon Pennine VII/Alexander T Type C49F working on service 597 from Glasgow to Largs, which is a popular seaside resort with a pier and beach on the Firth of Clyde in North Ayrshire, about 33 miles from Glasgow.

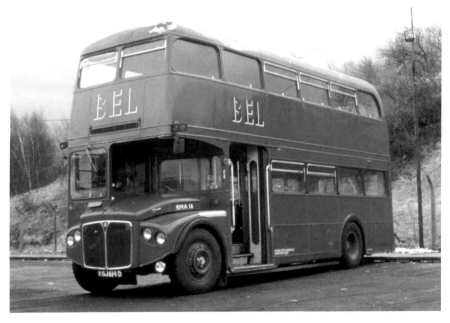

RMA16 KGJ 614D was an AEC Routemaster/Park Royal H67F purchased new by BEA, Ruslip as their 8221 in December 1966. It passed to London Transport as their RMA16 and is seen in Bus Engineering Limited livery for use on staff transport duties. It was acquired by Clydeside in February 1988 and initially used on similar duties at Paisley depot, but was later put into passenger service as a fifty-five-seater coach and renumbered as SRMA1. On disposal, it was exported to Sweden.

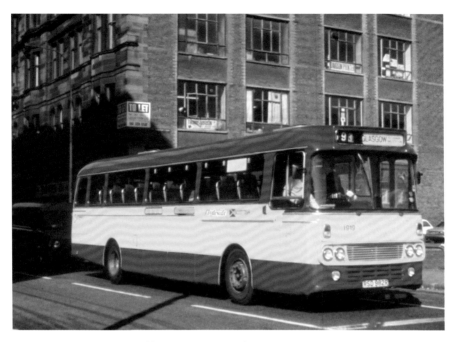

1919 RSD 982R was a Seddon Pennine VII/Alexander Y Type DP49F purchased new by Western in July 1977 and joining Clydeside in June 1985. It would have a short life, passing to PVS (dealer) Carlton in May 1987. These vehicles were not suitable for city work, with their narrow entrances and manual gearboxes.

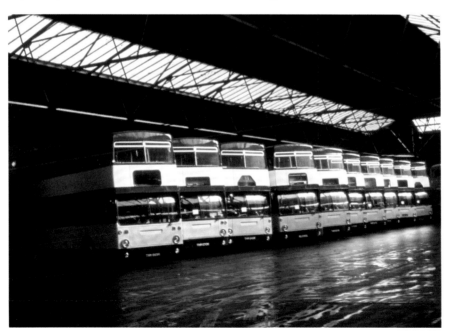

Ten of the ex London DMS Fleetlines are lined up in Greenock depot awaiting collection by Bexleybus. The repainting was done at Kilmarnock Works by SBG Engineering.

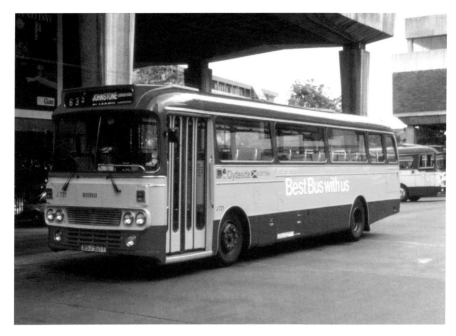

J721 BSJ 921T was a freshly outshopped Leyland Leopard PSU3E/4R/Alexander Y Type B53F seen in Glasgow's Anderston bus station, complete with 'Best Bus' decals. These vehicles were great workhorses and very reliable in service.

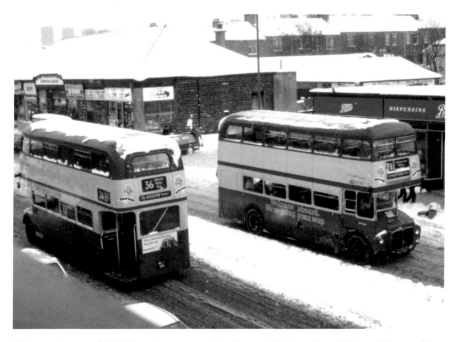

RM 367/391 and WLT 367/91 pass each other on Paisley Road West while working on the busy Glasgow–Johnstone corridor. This picture was taken from the roof of the Safeway store in Cardonald in near freezing conditions, and I can remember trying to change films with numb hands.

J486 A173 UGB was working on the Scottish Citylink Edinburgh–Gourock service on a rather more pleasant day. It was a Leyland Tiger TRCLXC/2RH/Plaxton Paramount Express 3200 C49F purchased new by Western in April 1984 and photographed here in the Scottish capital.

158 C158 FDS was a Dennis Dominator/Alexander R Type H79F purchased new in August 1985. It was converted to coach spec in December 1986 and is seen near Inchinnan in the second version of Quicksilver livery. These buses were used on a combination of commuter services and private hires.

JO990 OMS 910W was an ex demonstration Leyland Olympian/ECW H77F new in February 1981, which has carried the liveries of Midland and Northern before coming south to join Clydeside. It is seen in Buchanan bus station Glasgow, and was based at Johnstone depot. It and another similar bus were swapped with Stagecoach in Perth for a batch of second-hand Leyland Leopards.

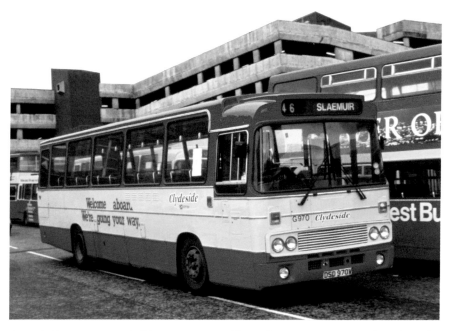

G970 DSD 970V was a Seddon Pennine VII/Alexander T Type C49F purchased new by Western in December 1979. It joined Clydeside in June 1985 and was reseated to B53F in March 1988. It didn't last long, however, as it was withdrawn by September 1988.

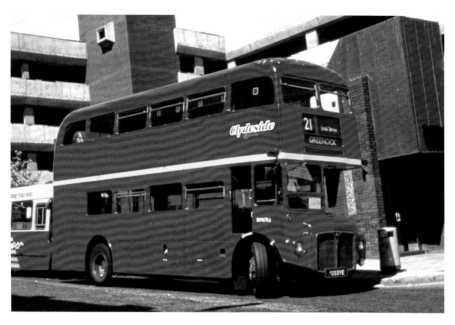

RM1703 703 DYE was an ex London Routemaster/Park Royal H64R purchased in
1987 for spares, but entered passenger service in April 1988 as an extra bus during
the Glasgow Garden Festival in this very London-like livery, and was photographed in
Kilblain Street in Greenock.

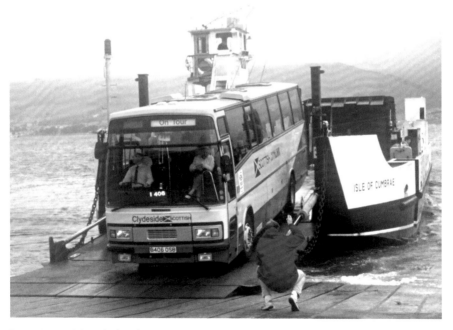

I406 B406 OSB Clydeside Dennis Dorchester/Plaxton Paramount 3500 C55F is on
a tour to Largs and Cumbrae. This atmospheric shot shows it being guided off of
the CAL-MAC ferry 'Isle of Cumbrae' by the late Robert Grieves, who worked for
Clydeside at the time, as the fog hangs over the Firth of Clyde.

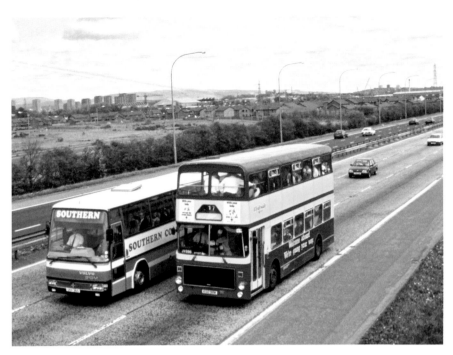

JV898 KSD98W. Two for the price of one! Clydeside Volvo Ailsa/Alexander AV Type H79F is overtaken at speed by Southern Coaches of Barrhead Volvo B10M/Caetano USV 365 (C708 KDS), new to Parks of Hamilton, on the M8 motorway near Renfrew.

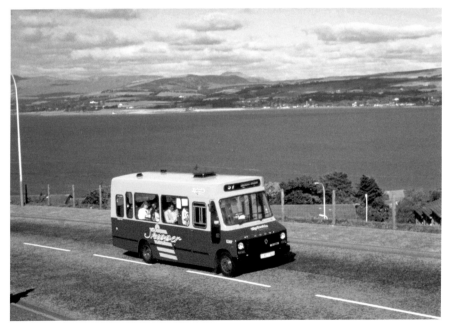

G307 D307 SDS was a Dodge S56/Alexander AM Type B25F purchased new in May 1987. It is seen when new, climbing the Clune Brae high above Port Glasgow with a splendid view of the River Clyde in the background.

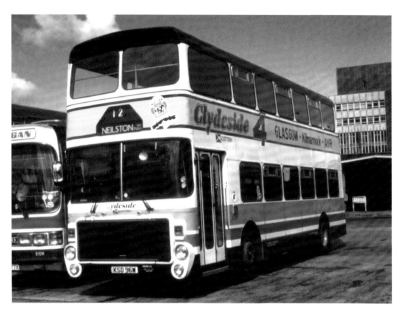

M96 KSD 96W was a Volvo Ailsa B55-10 Mk II/Alexander AV Type H79F purchased new by Western Scottish as their A96 in October 1980. It passed to Clydeside in June 1985 and was reseated as a coach. It was given this half-Western/half-Clydeside livery for use on the jointly operated service 4, which connected Glasgow and Ayr. These vehicles certainly had the speed, but problems were encountered with cross-winds as they crossed the moors and they were later changed for coaches.

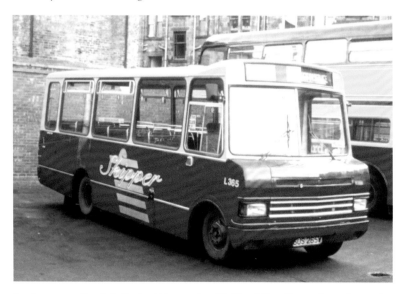

L365 was a Ford A Series/Alexander (Belfast) B27F purchased new by Central Scottish as their FS3 in November 1980. It was latterly a driver trainer before purchase by Clydeside in August 1987. It was very unreliable however, and saw very little service before sale to Strathtay Scottish as their SS3 in June 1988.

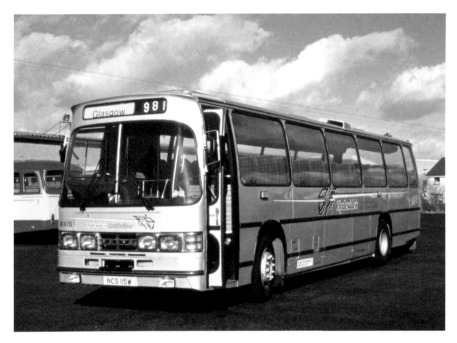

M415 NCS 115W was a Volvo B10M-61/Duple Dominant III C46Ft purchased new by Western in June 1981. It passed to Clydeside and was rebuilt to Dominant II spec with fifty-five coach seats and is wearing the original Quicksilver livery in this view taken at Thornliebank depot.

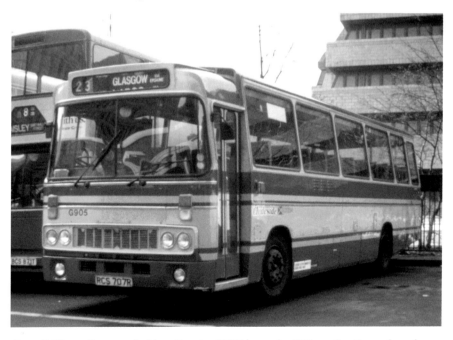

G905 RCS 707R was a Seddon Pennine VII/Alexander T Type C49F purchased new by Western in June 1977. It was given this unique version of the livery and was resting between duties in Anderston bus station.

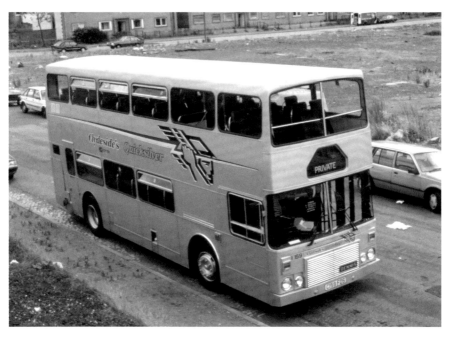

I159 C159 FDS was a Dennis Dominator/Alexander R Type H79F purchased new in August 1985. It was converted to coach spec by SBG Engineering at Kilmarnock Works and is seen on a private hire to the east end of Glasgow wearing the original Quicksilver livery.

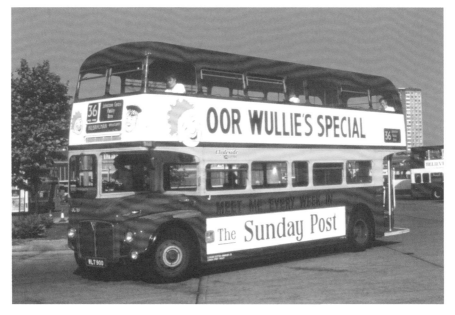

JC10 WLT 900 was an AEC Routemaster/Park Royal H72R purchased from London Transport in an accident-damaged condition in February 1988 and rebuilt over the next four months. As can be seen in this view taken in Glasgow, it carried advertising for *The Sunday Post* newspaper.

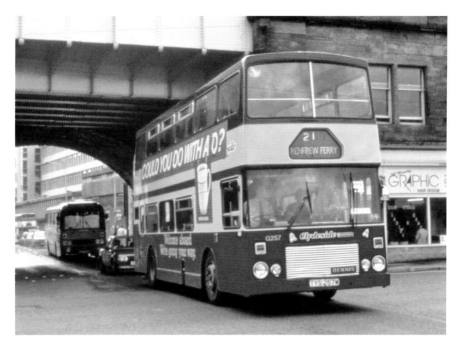

G257 TYS 257W was a Dennis Dominator/Alexander R Type new to Central Scottish as their D4 in July 1981. Unpopular due to the fitment of a Rolls-Royce engine, it passed to Eastern Scottish as EE57 in 1986 and onto Clydeside later that year. The engine was very thirsty and the bus tended to be used sparingly on duplicate journeys. It was leaving Paisley Smithhills Street on its way to Renfrew Ferry.

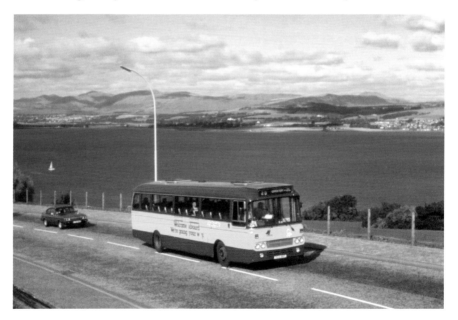

J688 YCS 98T was a Leyland Leopard PSU3E/4R/Alexander Y Type B53F new to Western in October 1978. It is seen in Port Glasgow with the River Clyde in the background.

MR876 ECS 876V was a Leyland Fleetline FE30AGR/Northern Counties H75F seen in Glasgow while carrying an all-over advert for Miller Homes. It was based at Thornliebank depot and working on service 1 to Eaglesham.

PV164 E864 RCS was a Volvo Citybus B10M-60/Alexander RV Type CH66F purchased new by Western Scottish as their V264 in November 1987. It was sent to work for Clydeside and had been on a private hire. It had tried to pass under the notorious Cook Street Bridge in Glasgow. This bridge has claimed many victims over the years as it deceives the drivers. There are actually two bridges and the first one is manageable, but the second one is much lower. The bus was quickly despatched to Johnstone Works for repairs and nobody knew anything about it. It's just our little secret!

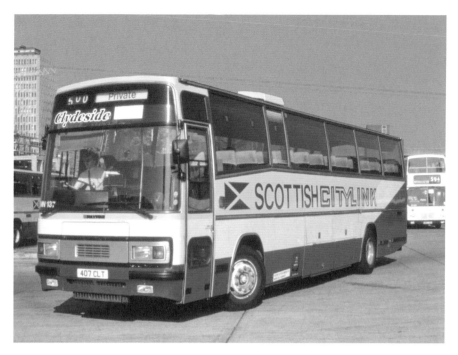

MN137 407 CLT (B407 OSB) was a Dennis Dorchester/Plaxton Paramount 3500 C55F purchased new in July 1985. It was re-registered to 407 CLT in November 1988 and is seen under Western control of the company.

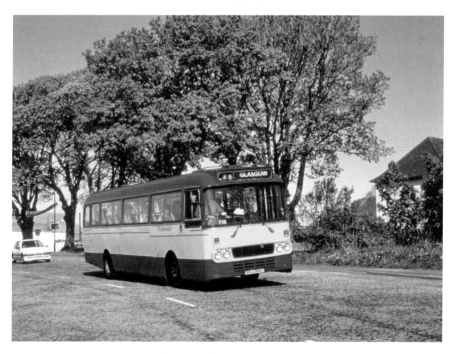

718 BSJ 918T was a Leyland Leopard PSU3E/4R/Alexander Y Type B53F seen in Inchinnan village on its way to Glasgow while working on service 23.

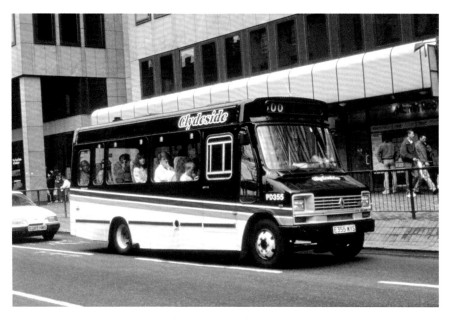

PD355 E355 WYS was a Renault S56/Alexander AM Type DP25F purchased new in January 1988. It is seen under Western control while working on Scottish Citylink service 500 linking Glasgow airport to the city.

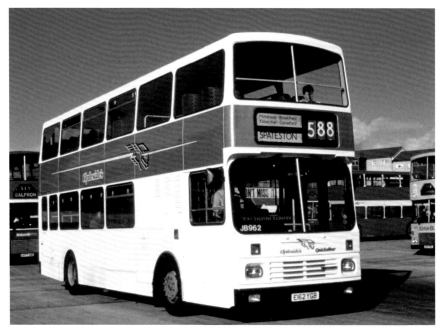

JB962 E162 YGB was originally ordered by Kelvin Scottish. This batch of Leyland Lion/Alexander RL Type CH86F were put up for sale on the open market before delivery, but as there were no takers the Scottish Bus Group were stuck with them and re-assigned the batch to Clydeside. It looked good in the Quicksilver coach livery as it worked a motorway express journey.

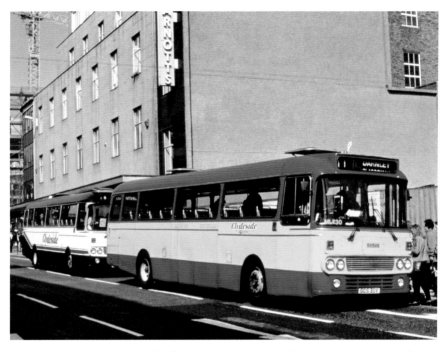

ML730 GCS 30V was a Leyland Leopard PSU3E/4R/Alexander Y Type B53F shown loading in Jamaica Street in Glasgow City Centre. The bus behind is painted in Western livery and this presented a mixed message to the travelling public.

642 TSJ 42S was another of the same combination seen passing through Renfrew town centre while working on service 24 bound for Nethercraigs in Paisley.

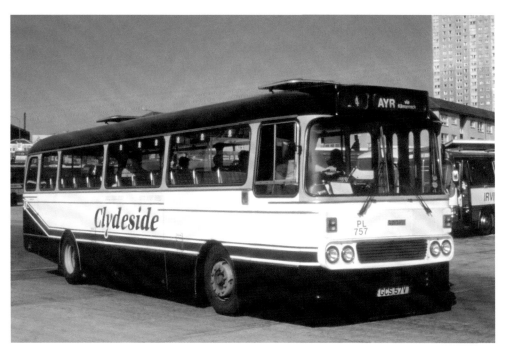

PL757 GCS 57V looked resplendent in full Western livery. Ironically, as Western were playing down the Clydeside image, the fleetnames became larger than ever. Some buses at Greenock actually received Western fleetnames.

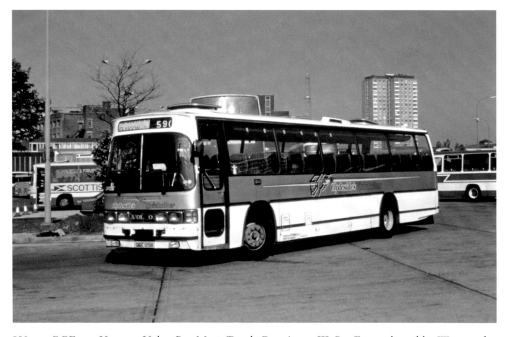

LV126 GGE 126X was a Volvo B10M-61/Duple Dominant III C46Ft purchased by Western for use on the Scotland–London services in February 1982. It passed to Clydeside and is seen rebuilt to Dominant II spec with fifty-five seats in Quicksilver livery.

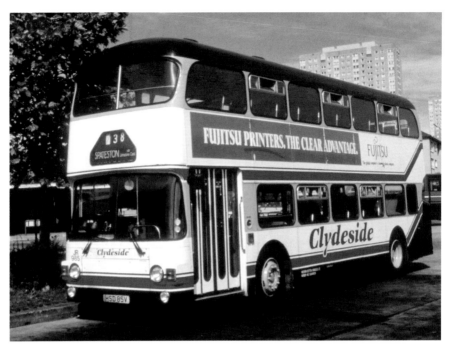

JR985 HSD 85V was an Alexander-bodied Leyland Fleetline purchased new by Western in July 1980. It passed to Clydeside in June 1985 but is seen in Western livery with Clydeside fleetnames in Buchanan bus station in Glasgow.

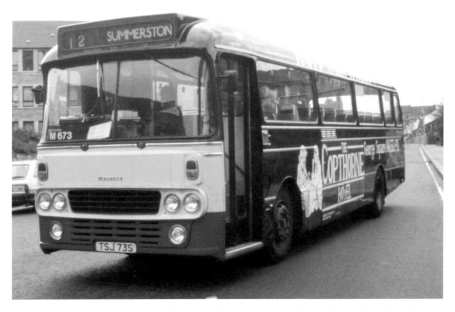

M673 TSJ 73S was a Leyland Leopard PSU3D/4R/Alexander Y Type B53F seen in Maryhill Road in Glasgow while carrying an advert for the Copthorne Hotel in George Square.

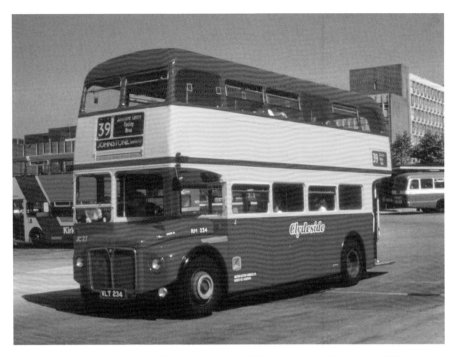

JC27 VLT 234 was an ex-London Transport AEC Routemaster/Park Royal H64R seen while under Western control. Western wanted rid of these buses almost immediately and purchased a rag-tag collection of ex-Kelvin Scottish Fleetlines, most of which needed vast sums spent on them to bring them up to fleet standard.

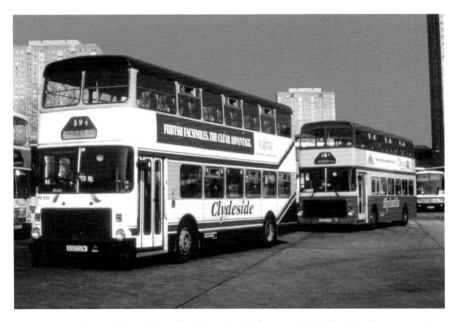

PV 907/12 KSD 107/112W neatly show the difference in the liveries then occurring. They were both Volvo Ailsa B55-10 with Alexander AV Type H79F bodywork awaiting the evening peak in Buchanan bus station.

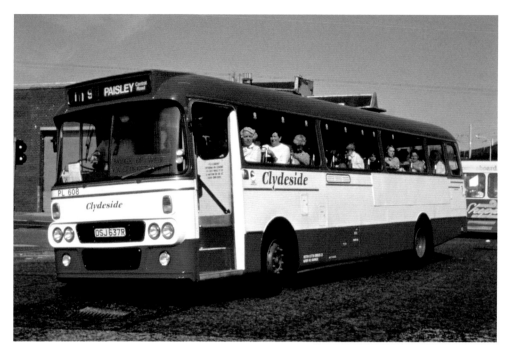

PL608 OSJ 637R was an elderly stick Leopard drafted in by Western to bolster the Clydeside fleet and was caught leaving Paisley while bound for Bridge of Weir.

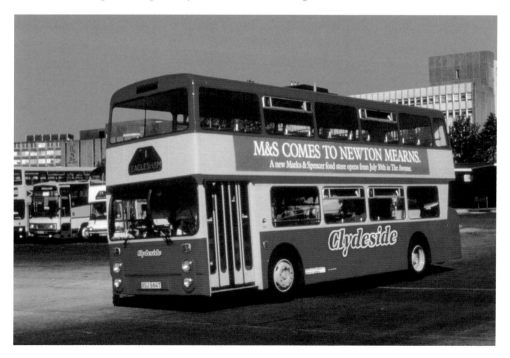

MR864 XSJ 664T was another Leyland Fleetline FE30AGR/Northern Counties H75F captured during the years of Western control. The use of grey wheels was interesting with the large Clydeside fleetnames carried.

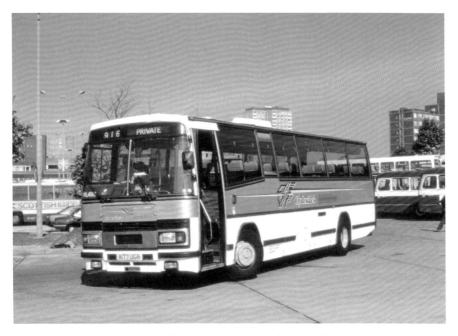

PL490 A177 UGB was a Gardner engined Leyland Tiger/Plaxton Paramount 3200 Express C49F repainted into the second version of Quicksilver livery.

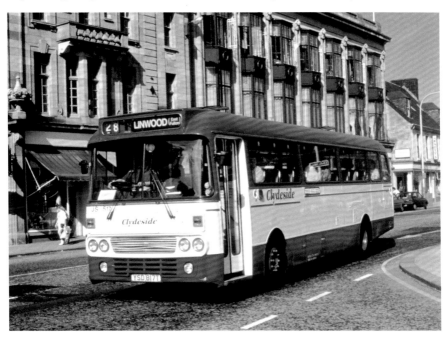

JS517 YSD 817T was a Seddon Pennine VII/Alexander Y Type B53F drafted into the Clydeside area after the demise of Graham's bus service in Paisley. Both Western and Strathclyde Buses were interested in purchasing Graham's, but it soon became apparent that whoever bought it would face competition from the other. In the end, the company had to close down and auction off the vehicles separately.

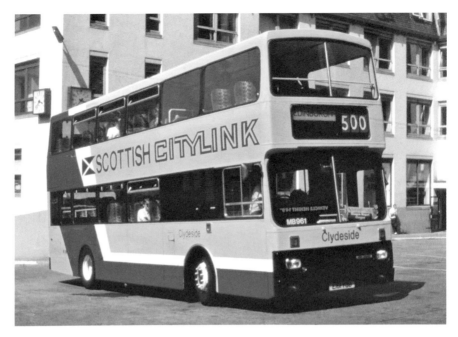

MB961 E161 YGB was another of the Leyland Lion order diverted from Kelvin Scottish. For a time, they were gainfully employed on the Glasgow–Edinburgh service for Scottish Citylink.

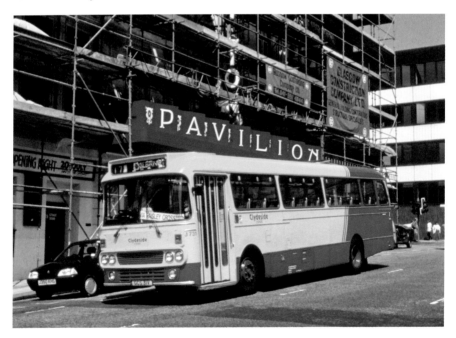

J731 GCS 31V was a Leyland Leopard/Alexander B53F seen freshly repainted in the Clydeside 2000 livery adopted after control passed to the staff. The buyout was unique within the ex-Bus Group companies in that it was an employee share ownership plan, with each member of staff having a £200 stake in the business.

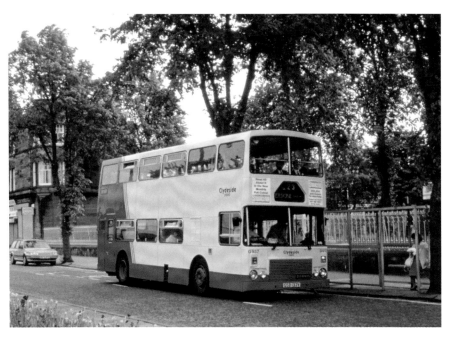

G937 GSB 137Y was a Dennis Dominator/Alexander RL Type H79F purchased new by Western in March 1983. It is seen passing through Renfrew in Clydeside 2000 livery. The new company ran just over 300 buses over 48 main routes and carried 35 million passengers a year. It had a turnover of £17 million and ran buses from six depots.

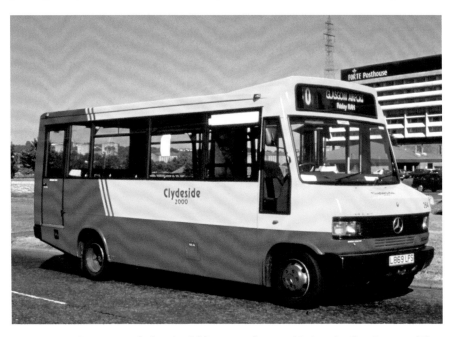

264 L869 LFS was one of a batch of fifteen new buses added to the fleet in 1994. They were all Mercedes 709D/Plaxton Beaver B25F purchased from the stock of Western Mercedes (dealer) based in Edinburgh.

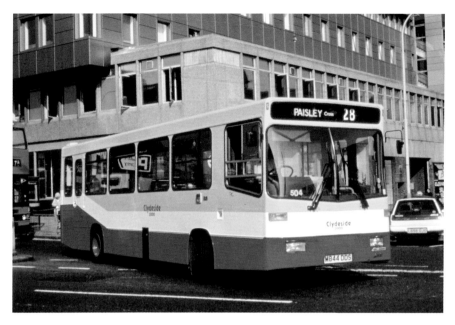

504 M844 DDS was one of seven Volvo B6-50/Alexander Dash B40F delivered in
1994. They arrived in stock white but were soon repainted. The addition of white
almost echoed the livery used on the Alexander T Types. There was supposed to be a
batch of Volvo B10B/Alexander Striders to follow, but control of the company passed
to British Bus before purchase was completed.

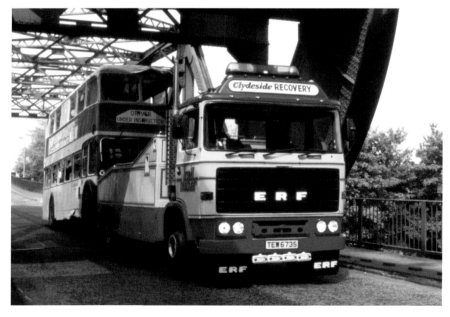

JW7 TEW 673S was a 1977 ERF Trailblazer 32-ton tractor unit purchased from PVS
(dealer) of Carlton in March 1988, and is shown crossing the swing bridge at Renfrew
towing the remains of a Bristol Lodekka driver trainer FPM 73C, which had crashed
into the River Cart on 22 May 1988.

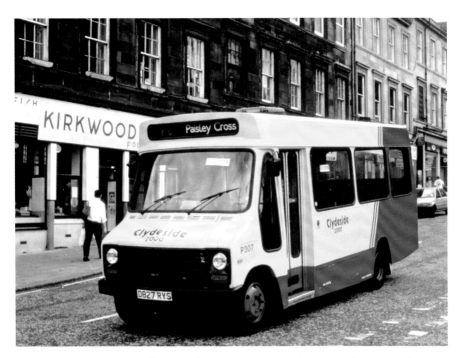

P307 D827 RYS was a Dodge S56/Alexander B25F purchased new by Central Scottish as their R27 in June 1987. Clydeside purchased it from Fife Scottish in 1992 and it was working the local Paisley Gilmour Street–Gockston service.

L478 TDU was a Volvo B6-50/Alexander Dash demonstrator working on the Paisley–Foxbar service early in May 1994.

216 E956 XYS. As part of the deal to lessen competition with Strathclyde Buses, which involved the closure of Thornliebank Garage and withdrawal of services in south Glasgow, SBL loaned six buses to Clydeside for one year. All were the same as this one, a MCW Metrorider MF150/55 B23F new to Strathclyde in December 1987. This had been M71, but all subsequently returned to SBL. Johnstone was the location of 216 at Houston Square on the town service.

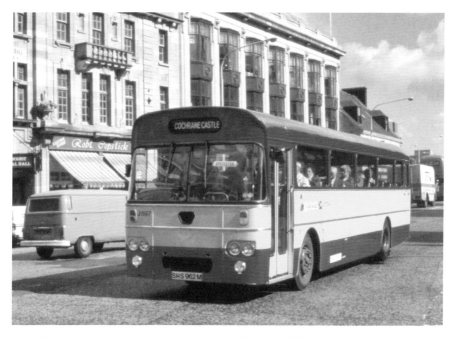

J597 SHS 962M was a Leyland Leopard PSU3B/4R/Willowbrook B53F purchased new by Paton Bros of Renfrew in March 1975. It passed to Western with the business in August 1979 before joining Clydeside in June 1985.

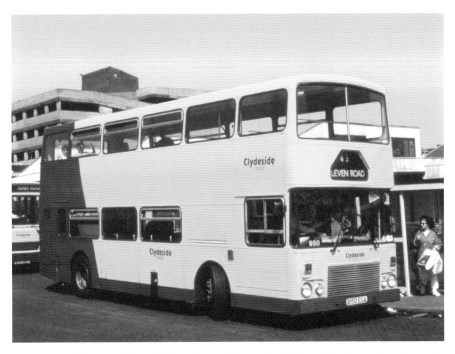

950 B150 EGA was a Dennis Dominator/Alexander R Type H79F purchased new in August 1985. It was captured while loading in Kilblain Street in Greenock repainted in Clydeside 2000 livery.

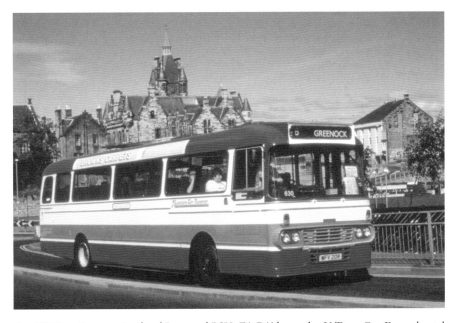

630 WFV 20R was a Leyland Leopard PSU3E/2R/Alexander Y Type C49F purchased new by Lancaster City Transport as their No. 20 in June 1977. It was operating a free service against Inverclyde Transport. Inverclyde had sold out to British Bus but a disagreement over non-payment saw them restart operations again.

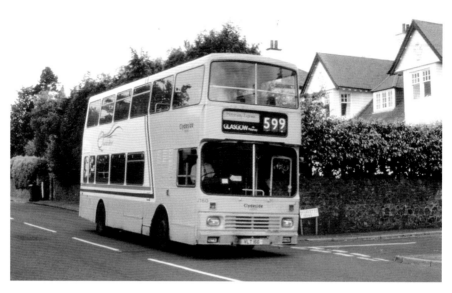

J160 VLT 166 (E160 YGB) was a Leyland Lion/Alexander R Type CH86F acquired in 1987 from a diverted Kelvin Scottish order. They featured Leyland TL11 engines and Voith transmissions and were excellent for express journeys. J160 was working in Kilmacolm.

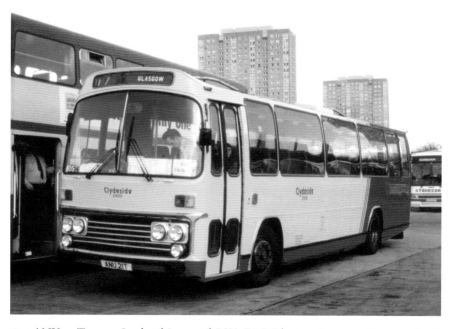

605 ANU 21T was a Leyland Leopard PSU3E/4R/Plaxton Supreme Express C49F purchased new by East Midland as their No. 21 in September 1978. It passed to Stagecoach for use in Perth before purchase as part of a batch of oddballs by Clydeside 2000. It is seen in an early version of the livery before the red lower panels were extended up to the beading.

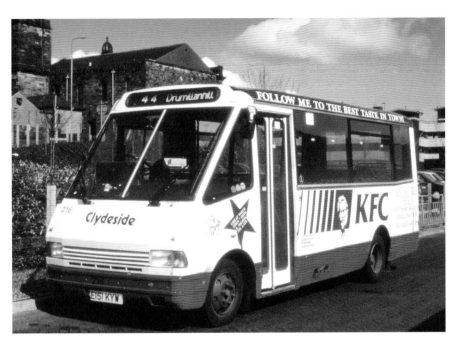

216 E151 KYW was an MCW Metrorider MF150/38 B25F purchased new by London Buses as their MR51 in November 1987. On disposal it passed to Darlington Transport and, on their demise, was snapped up by British Bus. It was pressed into service at Greenock still advertising KFC in Darlington.

K108 SAG was a London Buses Dennis Dart/Plaxton Pointer B28F borrowed for demonstration and seen loading at Paisley Cross while working on the former Graham's bus service to Linwood.

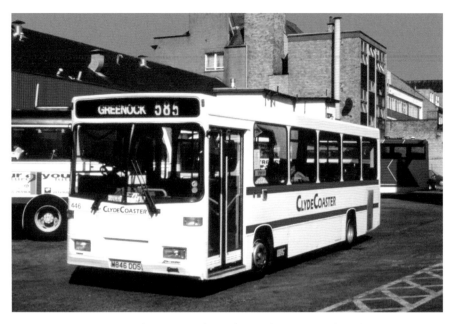

446 M846 DDS was a Volvo B6-50/Alexander Dash B40F purchased new in 1994. It is seen in Ayr bus station in 'Clydecoaster' livery. Vehicles of AA Buses, A1 Service, Clyde Coast, Western and Clydeside all carried this livery to try and stem heavy competition from the Argyll Group between Greenock and Ayr.

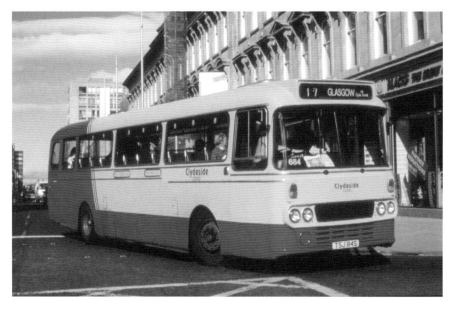

684 TSJ 84S was a Leyland Leopard PSU3D/4R/Alexander Y Type B53F new to Western SMT in January 1978 as L2724. It remained with Western after the 1985 split and received a broadside advert for Ayr College while being renumbered to AL724 and later L684. It passed to Clydeside 2000 in 1991 when Western was privatised and the northern depots were hived off, and is seen turning into Rose Street in Glasgow city centre. On disposal, it would pass to Lough Swilly (377) and become 78-DL-647.

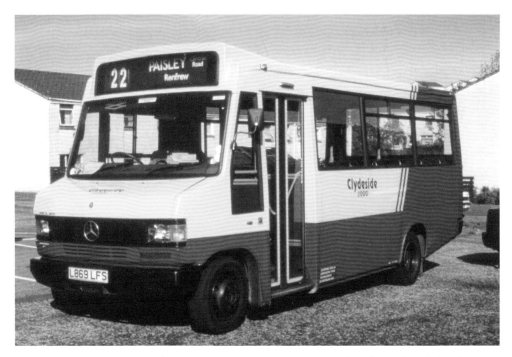

264 L869 LFS was a Mercedes 709D/Plaxton Beaver B25F purchased new by Clydeside 2000. It was photographed in Sempill Avenue in Erskine which was the terminus for service 22 which linked Paisley to Erskine via Renfrew. This bus was infamous on account of its heavy clutch and was one to be avoided if at all possible.

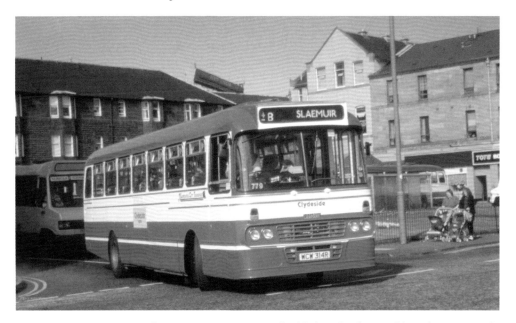

779 WCW 314R was another ex-Lancaster Leopard added to the fleet and based in Greenock. There were proposals to set up a low-cost unit known as Blue Bus but the scheme came to nothing.

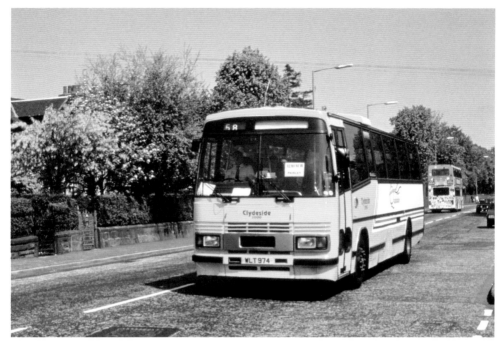

I177 WLT 974 (A177 UGB) was a Plaxton Paramount-bodied Leyland Tiger seen in Renfrew working on service 58. It is bound for Paisley Cross in the Quicksilver coach livery.

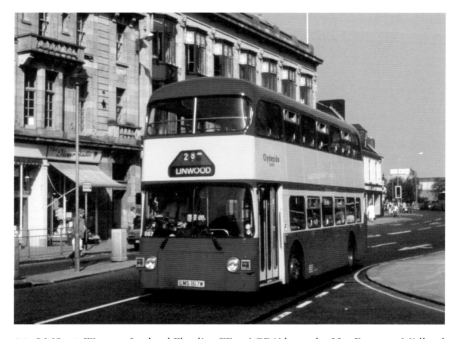

867 LMS 167W was a Leyland Fleetline FE30AGR/Alexander H75F new to Midland Scottish as MRF 167 in September 1980. It passed to Kelvin Scottish in June 1985 and was purchased by Western in 1989 as a Routemaster replacement vehicle.

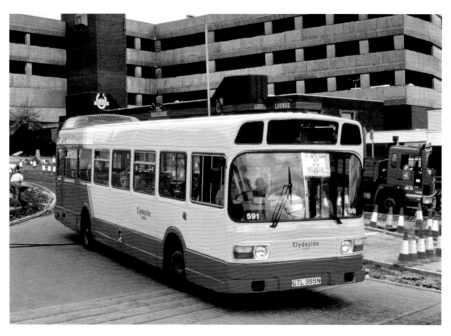

591 GTL 355N was a Leyland National B49F new to Lincolnshire in May 1975. It then passed to Stagecoach before reaching Inverclyde Transport and was included in the deal when Clydeside bought that company out.

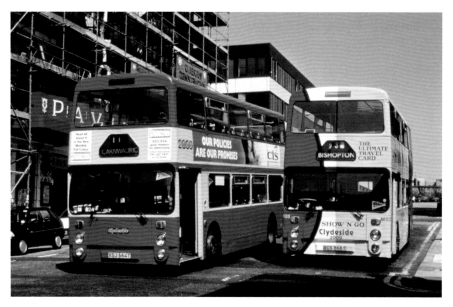

Renfield Street in Glasgow and two of Clydeside's Northern Counties-bodied Leyland Fleetlines are seen in service. On the left, M824 heads out of the city to Carnwadric as a No. 11, while the bus on the right is M828, which although carrying Thornliebank codes is actually an Inchinnan based bus. It is working on service 23 to Bishopton. The building in the background is Glasgow's famous Pavillion Theatre, which was built in 1904 and still going strong.

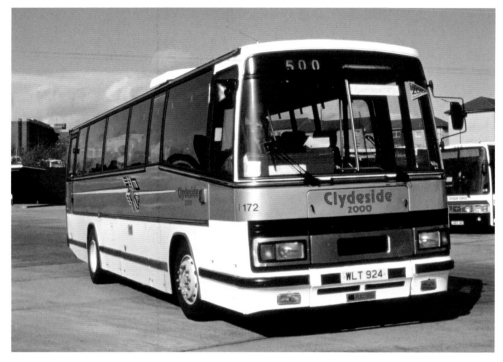

I172 WLT 924 (A172 UGB) was a Plaxton Paramount-bodied Leyland Tiger seen in Glasgow working on Scottish Citylink service 500 bound for Gourock.

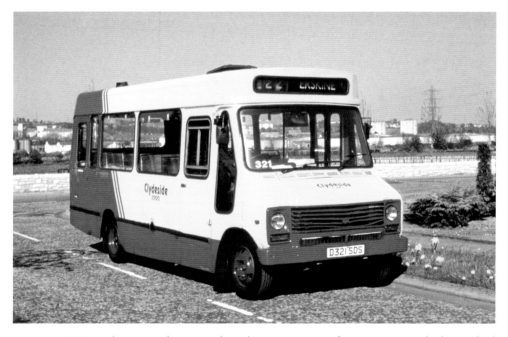

321 D321 SDS was known to drivers as 'dusty bin' on account of its poor steering lock. You had to leave about 20 feet to pull out from the bus in front! It was a Dodge S56/Alexander B25F and is seen near Erskine Bridge.

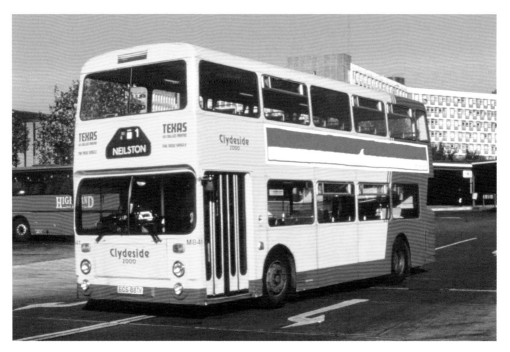

M841 ECS 881V was the only NCME-bodied Leyland Fleetline to receive this livery and is seen leaving Glasgow for Neilston.

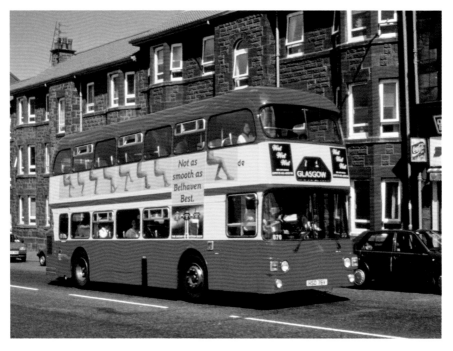

876 HSD 76V was an Alexander-bodied Fleetline new to Western in 1980. It lost its roof while with Clydeside and had the roof from DSD 732D grafted on in November 1985. It was always noticeable as the new roof had a flatter profile.

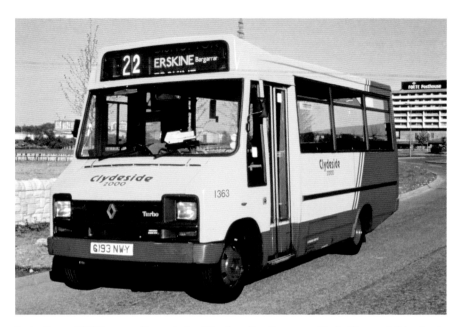

1363 G193 NWY was a Renault S56/Reebur B23F new to York City and District in April 1990. It was one of ten acquired in 1992 and allocated to Inchinnan depot. I always preferred driving this batch to the Alexander-bodied ones because they had a much lower centre of gravity and handled much better.

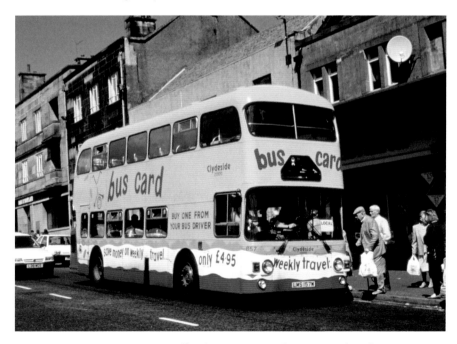

857 LMS 157W was new to Midland as MRF 157, but acquired in the Western era from Kelvin Scottish. This view catches it working on the Johnstone town service. The bus card advertised was available from the driver and required no user photograph, so was in a way transferrable.

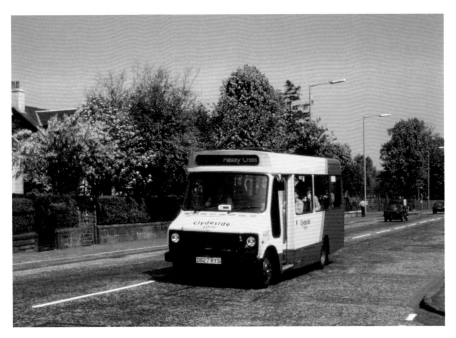

P307 P307 D827 RYS was a Dodge S56/Alexander B25F purchased new by Central Scottish as their R27 in June 1987. Clydeside purchased it from Fife Scottish in 1992 and it was working on the Erskine–Paisley service.

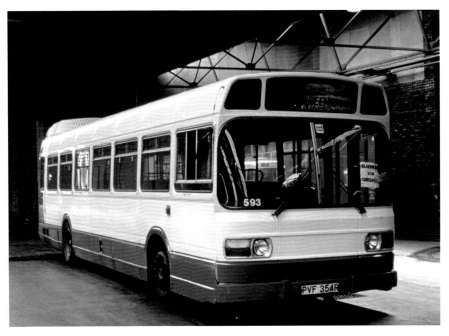

593 PVF 354R was a Leyland National new to Eastern Counties as LN 574 in January 1977. It passed to Cambus on the splitting of that company and on disposal joined Green's of Kirkintilloch. It then passed to Inverclyde Transport and then Clydeside with that business. It is seen in Greenock depot freshly repainted in Blue Bus livery.

628 MFR 17P was another ex-Lancaster Leopard and was caught bombing up the M8 motorway near Arkleston while bound for Glasgow. These vehicles were immaculate when purchased and worked very hard for the company.

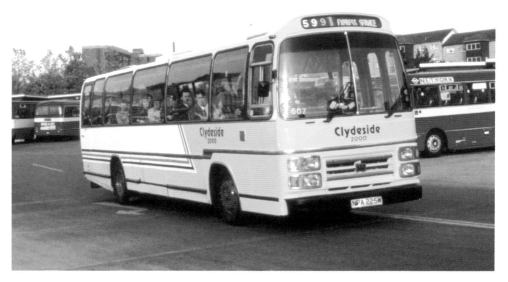

607 NPA 225W was a Leyland Leopard PSU3E/4R/Plaxton Supreme lV Express C53F new to London Country as their PL25 in May 1981 for Green Line services. On disposal, it passed to Rainworth Travel. It was one of a batch of various Leopards purchased from Stagecoach in 1993. This one entered service in bus livery but was later outshopped in Quicksilver colours for use on commuter services.

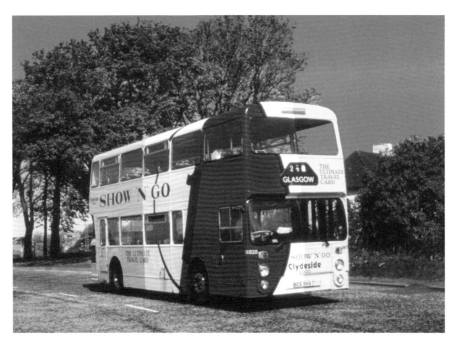

M828 BCS 868T was a Leyland Fleetline with Northern Counties body that came to Clydeside in 1985 when Western was split into two companies. It carries 'Show 'n' Go' livery, which allowed all-day travel with a ticket that was transferable between people. The depot code shown on the bus was for Thornliebank depot, but the vehicle was running out of Inchinnan depot on the 23 service, which linked Erskine to Glasgow via Renfrew.

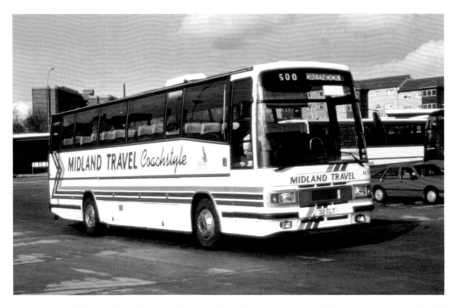

132 32 CLT (B402 CLT) was a Dennis Dorchester/Plaxton Paramount 3500 C55F purchased new in June 1985. It was carrying Stagecoach livery for use on feeders for coach tours operated by Midland Travel from Scotland, although working for Scottish Citylink in this view.

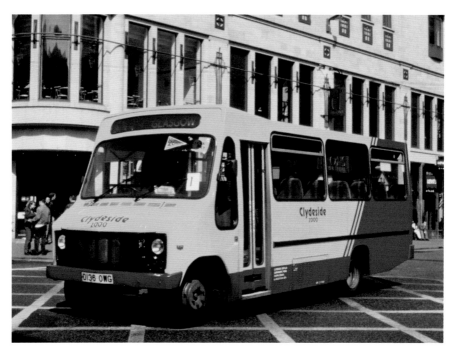

371 D136 OWG was a Dodge S56/Reebur DP25F new to South Yorkshire Transport in 1987 but purchased by Clydeside in 1992. It was crossing the junction of Argyle Street and Jamaica Street in Glasgow City Centre.

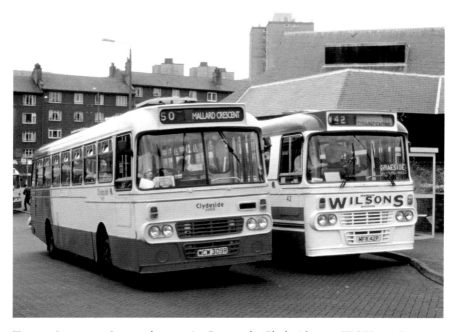

Two ex-Lancaster Leopards meet in Greenock. Clydeside 774 WCW 309R passes Wilson's MFR 42P in Kilblain Street. Clydeside added fifty-one second-hand Leopards to the fleet in 1993 from Lancaster, Stagecoach, Kelvin Central and Cleveland Transit.

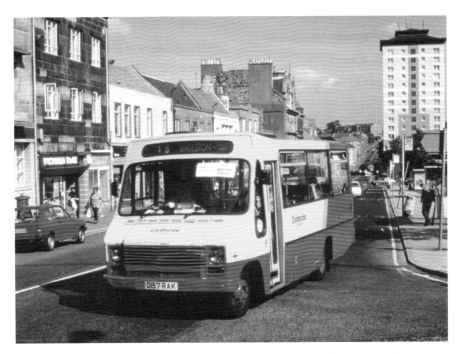

373 D157 RAK was another ex-South Yorkshire Dodge S56/Reebur B25F added to the fleet in 1992. It was passing through Johnstone en route for Spateston.

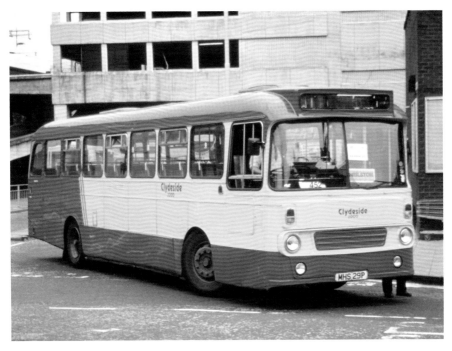

452 MHS 29P was a manual gearbox Leopard new to Central SMT as T251. The livery on this one was unique, featuring a red roof on top of normal Clydeside 2000 livery. It was exiting Paisley's Central Way.

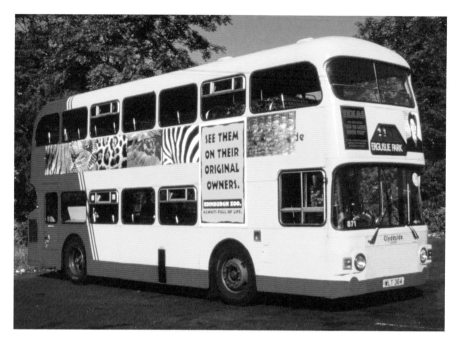

871 WLT 364 (HSD 71V) was a Leyland Fleetline FE30AGR/Alexander H75F and carries a rather ironic advert as Clydeside MD Tony Williamson thought the fleet name was Clydeside Zoo and not Clydeside 2000. In the company's defence, they did operate Lions, Tigers and Leopards!

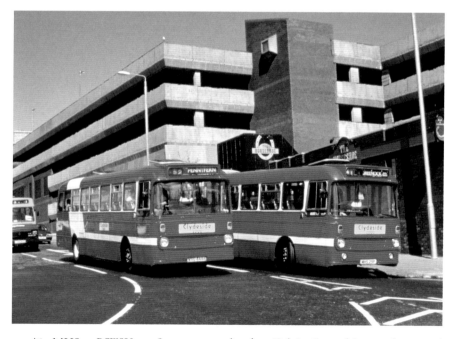

452/65 MHS 29P/WSU 449S were a couple of ex-Kelvin Central Leopards pressed into service in their previous livery at Greenock. Twenty-two of these manual gearbox Leopards joined the fleet in 1993.

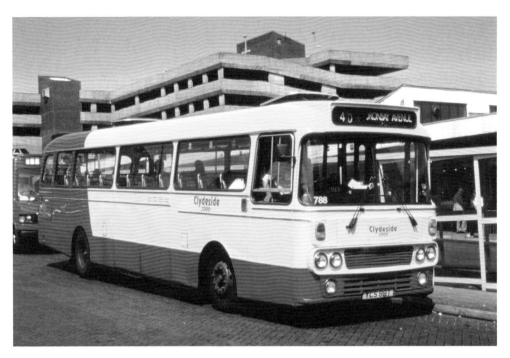

788 YCS 88T was a Leyland Leopard PSU3E/4R/Alexander Y Type B53F purchased new by Western as L2799 in October 1978. To speed up repainting, outside contractors were used and applied this simpler style omitting the two thin, red lines at the rear wedge.

M93 OGM 602M was acquired as a driver trainer. It was a Leopard PSU3C/3R new to Central SMT as T202 in 1974 and was being used in Greenock.

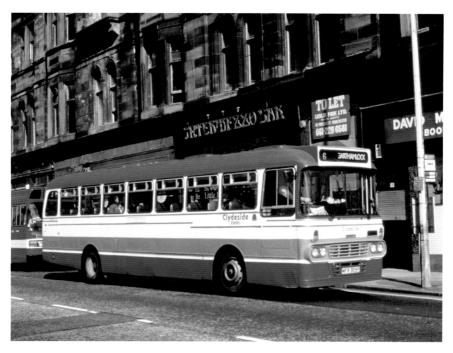

771 MFR 305P was another ex Lancaster Leopard pressed into service in Glasgow on service 16 to Garthamlock. The condition of these buses was a credit to Lancaster City Transport.

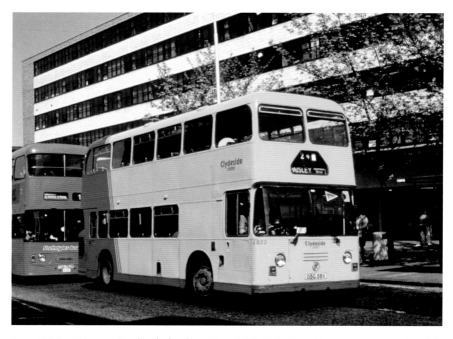

J822 OSG 58V was a Leyland Fleetline FE30AGR/ECW H75F new to Eastern Scottish but acquired from Kelvin via Western. It is seen in Paisley while working on service 24 from Glasgow.

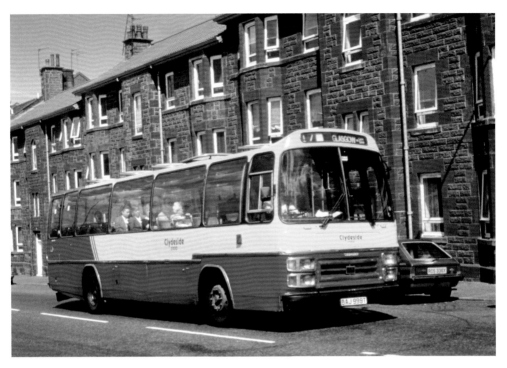

612 BAJ 999T was a Plaxton-bodied Leopard purchased from Cleveland Transit in 1993 and is shown passing through Johnstone on service 17 from Largs.

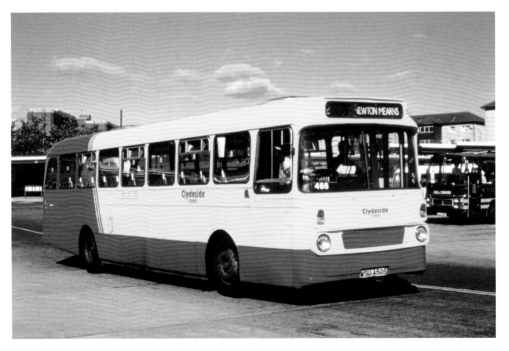

466 WSU 450S was another ex-Kelvin Central Leopard, but seen fully repainted in this view taken in Glasgow. It was a backward step using manual gearbox buses on city work again.

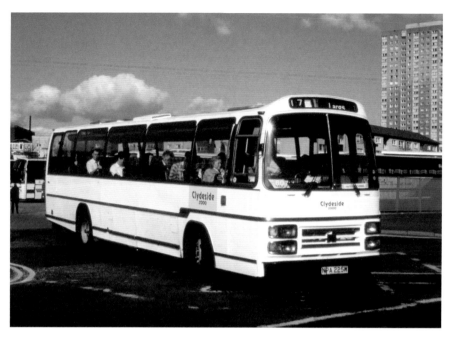

607 NPA 225W was a Leyland Leopard PSU3E/4R/Plaxton Supreme lV Express C53F new to London Country as their PL25 in May 1981 for Green Line services. On disposal it passed to Rainworth Travel. It was one of a batch of various Leopards purchased from Stagecoach in 1993.

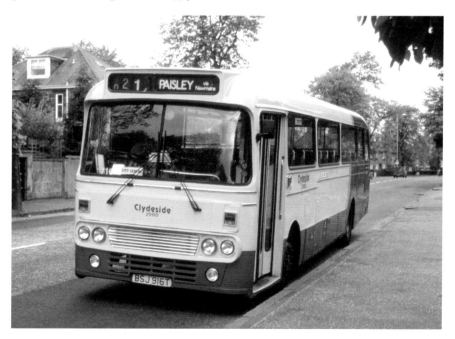

716 BSJ 916T was an Inchinnan based Leopard and was photographed in Renfrew about to start its day's work on service 21, which covered the old route operated by Paton's of Renfrew.

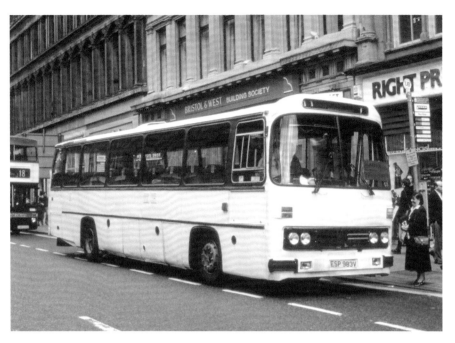

616 ESP 983V (KVV 240V) was a Willowbrook 003 C49F-bodied Leopard new to United Counties. It passed to Stagecoach in Scotland and ran as 4582 SC before sale to Clydeside in 1993. This view shows it pressed into service in Glasgow City Centre and it looked really rough.

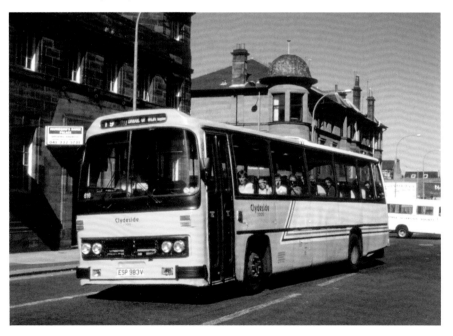

616 ESP 983V (KVV 240V) seen again when fully repainted. A handful received Quicksilver colours while the rest were in bus livery. It was operating on the Bridge of Weir service from Paisley Central Way.

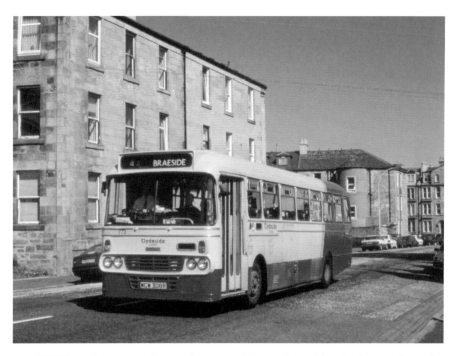

773 WCW 308R was another ex-Lancaster Leopard working in Greenock on the local service to Braeside.

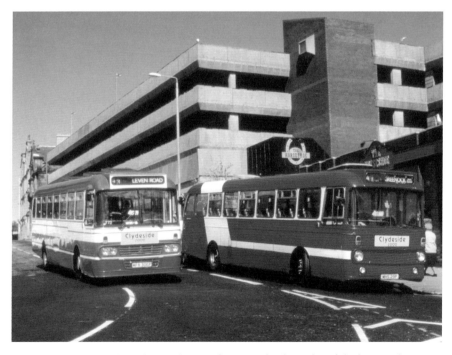

772/452 MFR 306P/MHS 29P. Greenock was indeed a colourful place at this time. The company seemed to be in crisis but the fleet was fascinating with all sorts of second-hand buses.

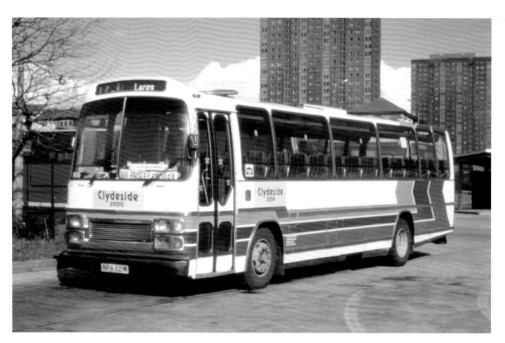

606 NPA 221W was an ex-Rainworth Travel Plaxton Supreme-bodied Leopard pressed into service in Stagecoach livery. It was rumoured that Strathclyde Buses feared the company had been taken over by a major group and a few sleepless nights were had before the truth was known.

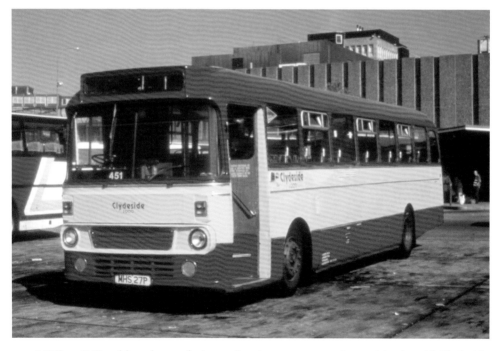

451 MHS 27P. To add to the confusion, a few buses were outshopped in the old Clydeside Scottish livery including this ex-Kelvin Central Leopard. Services in South Glasgow were abandoned in November 1994 with the closure of Thornliebank depot.

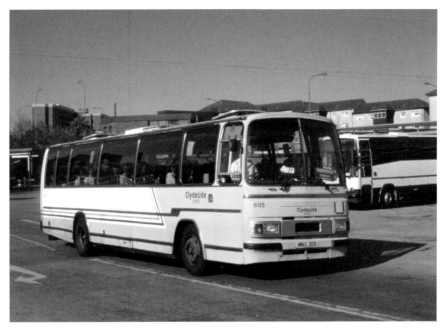

605 MNX 305 (LTY 559X) was a Leyland Leopard PSU3F/5R/Plaxton Supreme C46F new to Rochester and Marshall in February 1982. Clydeside purchased it from Northumbria in 1994 for use on service 599, which linked Glasgow and Kilmacolm.

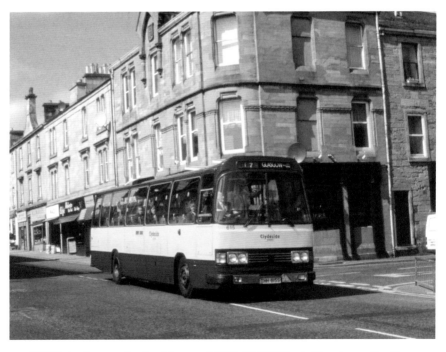

615 THH 615S was a Leyland Leopard PSU3E/4RT/Duple Dominant C53F new to Cumberland in September 1977. It passed to Hunter's of Seaton Delavel before reaching Northumbria and Clydeside 2000. It was passing through Johnstone on service 17.

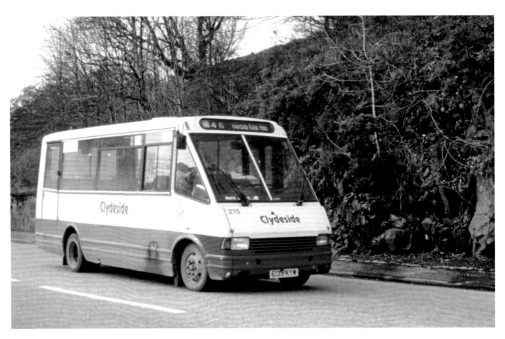

215 E135 KYW was an MCW Metrorider MF150/38 B25F new to London Buses as MR35 in November 1987. It passed to Darlington Transport before purchase by British Bus and was pressed into service in its previous livery.

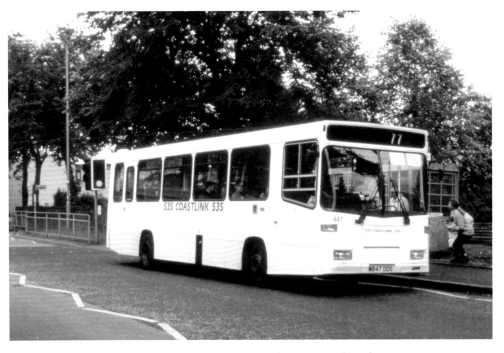

447 M847 DDS was a Volvo B6-50/Alexander Dash B40F purchased new in 1994. It is seen after transfer to Greenock and carried short-lived lettering for the Coastlink service. Ashton Coaches forced the names to be removed after a court battle.

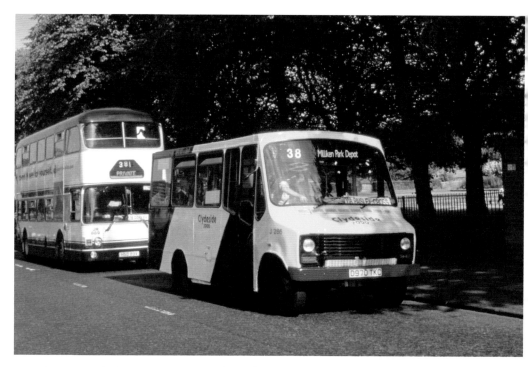

J286 D970 TKC was an ex-Merseyside Dodge S56/Northern Counties, which was hired from a dealer during a vehicle shortage. It was soon purchased by Rapson's of Inverness.

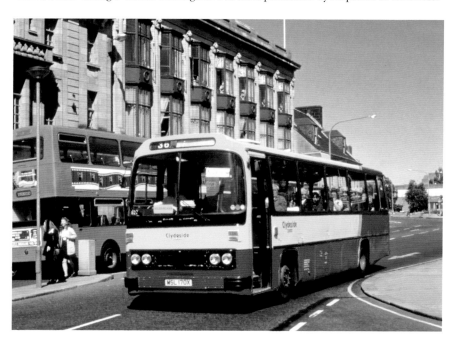

627 MSL 170X (VKN 833X) was a Leyland Leopard/Willowbrook 003 C47F new to Maidstone and District in May 1982. It is shown at Paisley Cross in its new livery looking quite smart, but the bodywork was very poor on these buses.

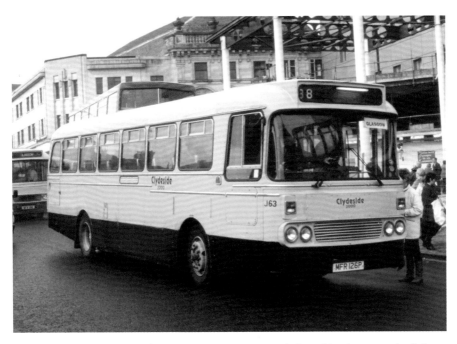

J63 MFR 126P was another ex-Lancaster Leopard, but this time acquired from Stevenson's of Uttoxeter. Stevenson's had purchased Edinburgh Transport before British Bus purchased the business. When the Edinburgh operations were closed down a couple of buses found their way to Clydeside and J63 was captured at Paisley Cross.

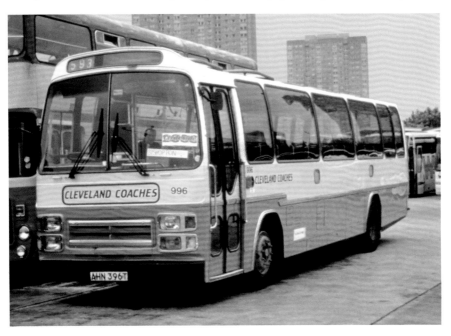

996 AHN 396T was a Plaxton-bodied Leopard purchased from Cleveland Transit and quickly pressed into service before being repainted. It operated from Inchinnan depot and was caught in Glasgow.

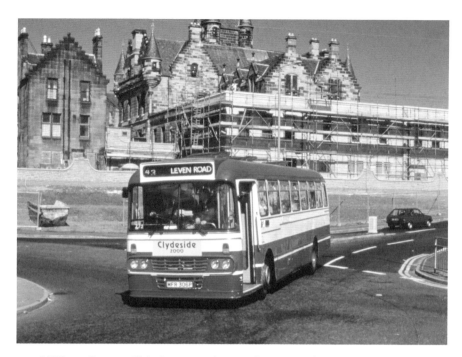

772 MFR 306P was still in Lancaster livery when pressed into service in Greenock and is seen on the ex-Inverclyde Transport route to Leven Road.

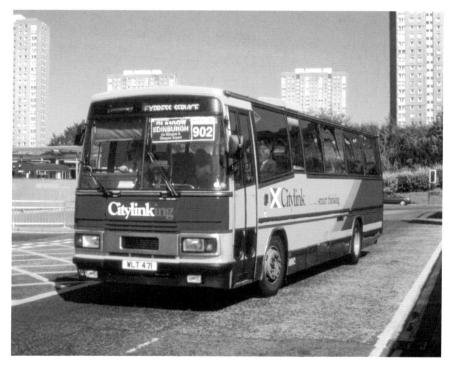

WLT 471 (A181 UGB) was a Leyland Tiger/Plaxton Paramount 3200 C49F seen in Scottish Citylink livery while working on the Glasgow–Edinburgh service.

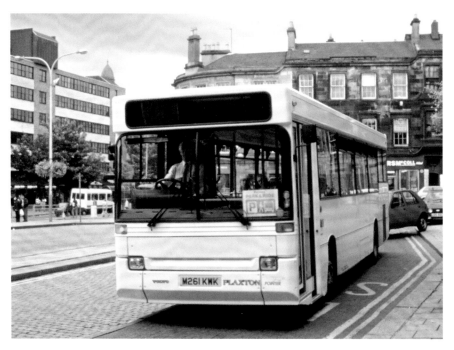

M261 KWK was a Volvo B6-50/Plaxton Pointer B40F used by the company as a demonstrator. It was working on the Paisley Park and Ride Service in 1995.

602 UAU 17S was a Leyland Leopard/Duple Dominant C49F new to East Midland in August 1977. It passed to Clydeside in 1993 and is shown in Greenock, but sadly it was short-lived as it was involved in an accident and cannibalised.

M298 D895 MDB was a Dodge S56/Northern Counties B20F new to Greater Manchester PTE in 1987 but purchased via Merseyside Transport in 1991. It was passing through Renfrew Cross while bound for Paisley.

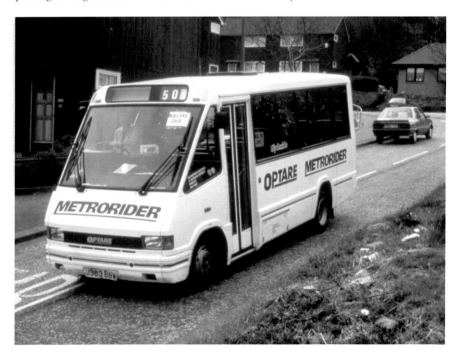

J363 BNW was an Optare Metrorider MR09 B23F used on demonstration duties on service 50, which ran from Greenock Town Centre to Mallard Crescent.

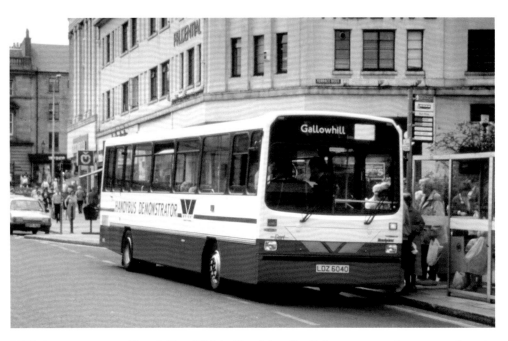

LDZ 6040 was a 1992 Dennis Dart/Wright Handybus B40F demonstrator that was used on the Paisley Cross–Gallowhill service.

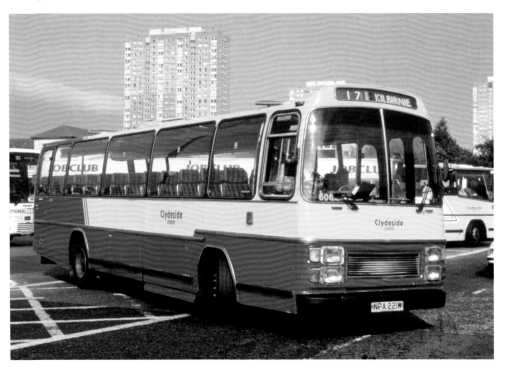

125 606 NPA 221W was an ex-Rainworth Travel Plaxton Supreme-bodied Leyland Leopard pressed into service in Stagecoach livery. It is seen here after a full repaint leaving Glasgow on the Kilbirnie service 17.

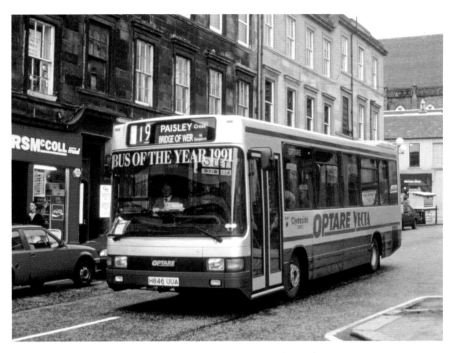

H846 UUA was a MAN 11.190/Optare Vecta B41F used as a demonstrator on service 19, which connected Paisley with Bridge of Weir.

601 PVB 804S was a Leyland Leopard PSU3E/4R/Duple Dominant C49F new to East Kent as their 8804 in March 1978. It arrived via Stagecoach and is shown in Greenock's Kilblain Street looking very smart.

636 TSJ 36S is shown in the British Bus inspired livery, which added white and dropped the 2000 tag from the fleetname. The new fleetname style used was known as 'Renfrew Font'. 636 was a Leopard, shown loading in Paisley Gilmour Street.

771 MFR 305P is another ex-Lancaster Leopard seen in the later livery in Greenock while working on the local service to Pennyfern.

273 F32 CHD (F776 OYX) was a FIAT 49.10/Robin Hood B19F acquired with the business of C&H Coaches of Johnstone. It had a short life after an electrical fire led to its withdrawal.

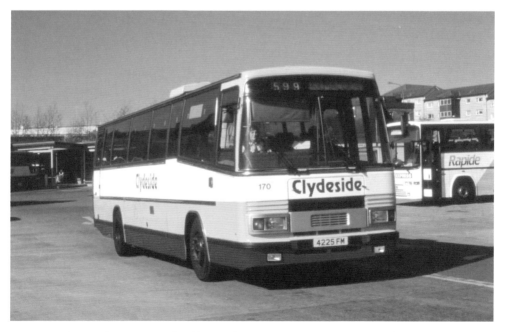

4225 FM (A170 UGB) was a Leyland Tiger/Plaxton Paramount 3200 C49F shown in yet another version of the livery. It was working on service 599 bound for Kilmacolm.

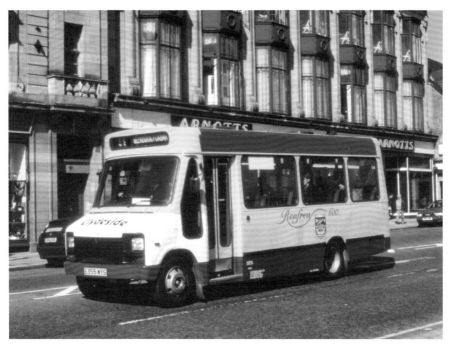

355 E355 WYS was a Renault S56/Alexander DP25F but reseated to B25F. It was celebrating 600 years of the founding of Renfrew, which gained royal burgh status in 1397 and became the county town of Renfrewshire.

256 L861 LFS was a Mercedes 711D/Plaxton Beaver B25F purchased new in 1994. The 711D was the turbo-charged version of the 709D chassis. It was caught in Paisley's Love Street.

508 M108 RMS was a Scania N113CRL/East Lancs European B51F purchased new in 1995. This view shows it newly delivered to Inchinnan depot before number blinds were fitted.

442 M842 DDS was a Volvo B6-50/Alexander Dash B40F purchased new in 1994 in perhaps the most successful version of the livery. It was operating through Erskine on service 23 from Glasgow.

805 M931 EYS was a Dennis Lance/Plaxton Verde B49F from a batch diverted from a North Western order. They were allocated to Johnstone but were very unreliable and quickly disposed of to their original intended destination.

218 P218 SGB was an Optare Metrorider B29F purchased new in 1996 and allocated to Inchinnan depot. It was working on the Foxbar–Glasgow Airport service when photographed in Paisley.

238 K96 RGA was a Mercedes 709D/Dormobile Routemaker B29F acquired with the business of Bridge Coaches of Erskine in 1997. It was unusually caught in Glasgow city centre working on the busy 23 service.

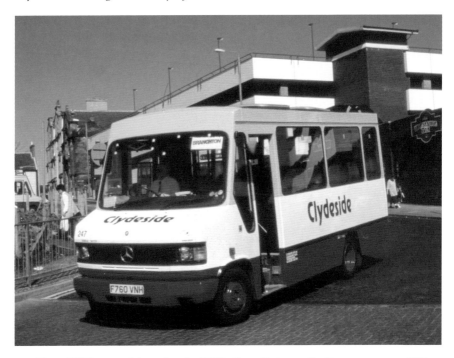

247 F760 VNH was a Mercedes 609D/Wadham Stringer C21F new as a non-PSV to Stoke Mandeville Hospital. It was acquired with the business of C&H Coaches of Johnstone in 1995. It is shown in Greenock and later had a destination box fitted.

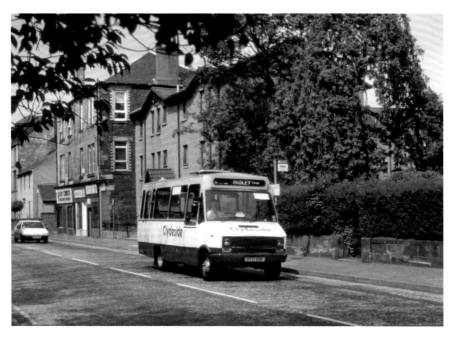

271 D371 SGP was an Iveco Daily 49.10/Elme Orion B22F new to United Transport before passing to Ribble. It was acquired by Clydeside in 1993 with the business of Goldline Travel.

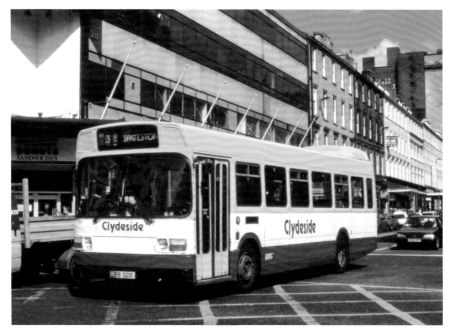

581 UPB 321S. Graham Cumming, chairman of Luton & District, promised the Clydeside staff that they would flood the area with buses and L&D would provide a fleet of Leyland Nationals and Lynxes once British Bus assumed control. This was it, the one and only bus sent! It was a Leyland National new to London Country.

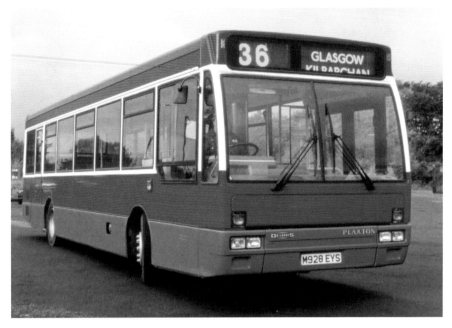

M928 EYS was a Dennis Lance/Plaxton Verde B49F seen at Johnstone ready for dispatch to North Western. This batch was replaced by more second-hand Leyland Leopards.

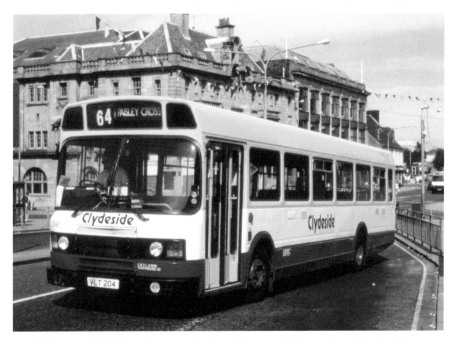

591 VLT 204 (BVP 822V) was a Leyland National NL116L11/1R B49F new to Midland Red (822) in May 1980. It then passed to Midland Fox as their 3822 before transfer by British Bus to Clydeside and was the only National 2 in the fleet. It was later re-registered to VLT 204 and then WDS 199V before being transferred to the McGill's of Barrhead fleet that had been purchased by Arriva.

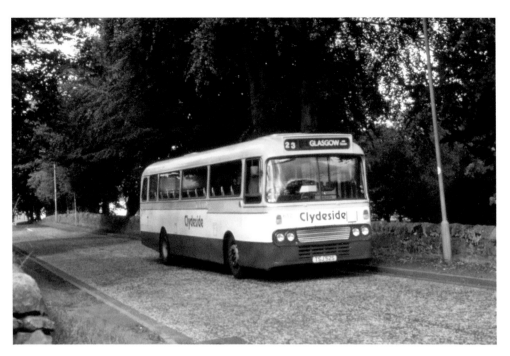

652 TSJ 52S was a Leyland Leopard/Alexander Y type B53F seen passing through Erskine on its way to Glasgow on service 23.

888 HSD 88V was a Leyland Fleetline FE30AGR/Alexander H75F. It received this advert but only managed a week in service before a broken chassis led to its early withdrawal.

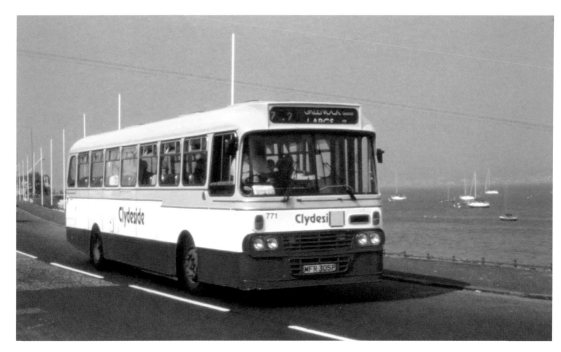

771 MFR 305P was skirting the Firth of Clyde near Gourock while working on the Largs–Greenock service.

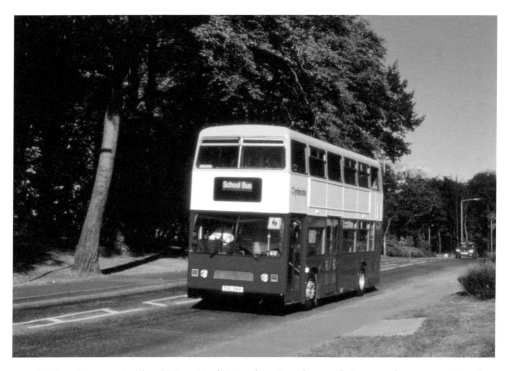

924 CUL 94V was a Leyland Titan/Park Royal ex-London and Country but new to London Transport as their T94 in October 1979. It was on a school contract near Johnstone.

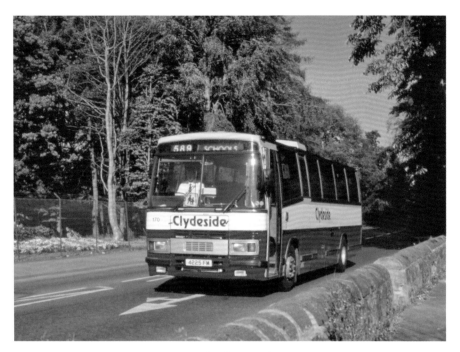

170 4225 FM (A170 UGB) was a Leyland Tiger/Plaxton Paramount 3200 C49F on a school journey. Many of these contracts were driven by inspectors and depot staff.

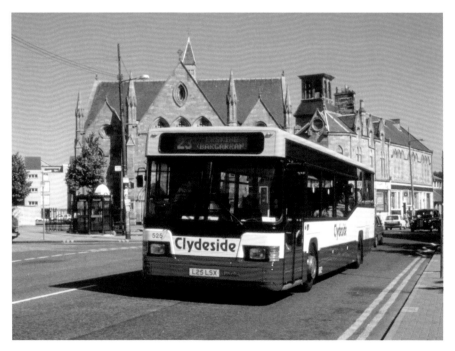

525 L25 LSX was a former Scania demonstrator delivered with the new batch to make up the numbers. It had an East Lancs body and could always be spotted by the black window surrounds. It was passing through Govan on service 23.

B505 PRF was a Ford
Transit acquired from
Midland Red North
for staff transport and
was doing a driver
changeover in Paisley.

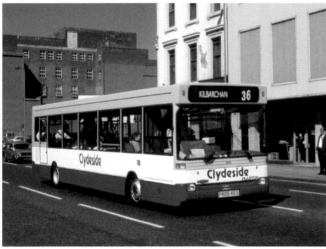

826 P826 KES was
a Dennis Dart SLF/
Plaxton Pointer B37F
purchased new in
1997 and allocated
to Johnstone depot. It
was caught in Glasgow
city centre on the busy
Kilbarchan service.

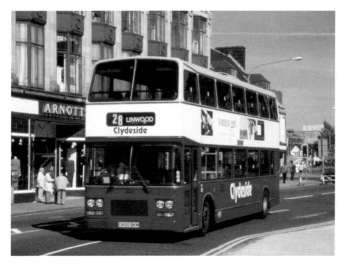

890 C450 BKM was
a Leyland Olympian
ONTL11/2R/ECW
CH73F purchased
from Northumbria in
1996 and was taking
a turn on the former
Graham's Bus Service
route to Linwood.

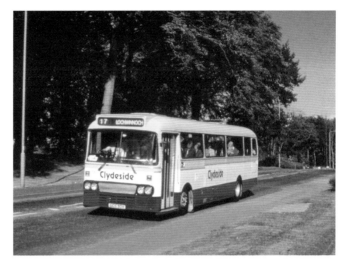

730 GCS 30V was a former Western Leyland Leopard caught as it passed through Johnstone on its way to Lochwinnoch on service 17.

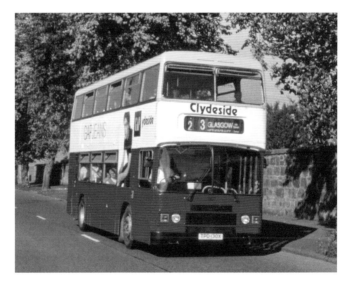

901 TPD 130X was a former London and Country Roe-bodied Leyland Olympian added to the fleet from Londonlinks in 1997, shown in Renfrew bound for Glasgow.

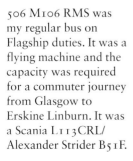

506 M106 RMS was my regular bus on Flagship duties. It was a flying machine and the capacity was required for a commuter journey from Glasgow to Erskine Linburn. It was a Scania L113CRL/ Alexander Strider B51F.

319 D319 SDS
was a Dodge S56/
Alexander B25F
seen on the Paisley
Cross–Gockston
service.

138 N138 YMS
was a Scania
K113CRB/Van
Hool Alizee C53F
purchased new in
1996 for Scottish
Citylink work.
It was based at
Greenock depot
and the drivers on
these duties were
on a lower pay rate
than service bus
drivers.

342 E342 WYS
was a Renault
S56/Alexander
B25F shown in
Bus Ticket Lottery
livery. Each depot
had a bus in this
scheme and every
week passengers
put their name and
address on the back
of every bus ticket
they had used and
a winner would be
drawn for a £100
prize.

837 P837 KES was a Plaxton-bodied Dennis Dart SLF wearing Gallowhill Shuttle branding. The introduction of this upgraded service cleared rival operators out of this area.

804 P804 RWU was another Plaxton Pointer-bodied Dart SLF that carried ClydeCoaster livery and was loading at Irvine Cross on the service to Ayr.

401 M65 FDS was a Dennis Dart/Plaxton Pointer B40F purchased new in 1995. It was working for Scottish Citylink on the Glasgow city centre–airport service.

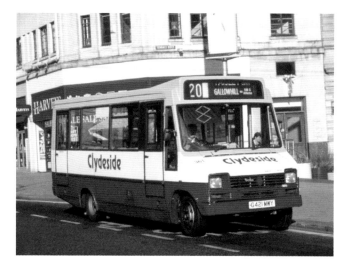

361 G421 MWY was a Renault S56/Reebur Beaver B23F purchased from Rider York in 1992, shown outside Paisley Piazza shopping centre while operating on service 20, which linked Johnstone and Gallowhill.

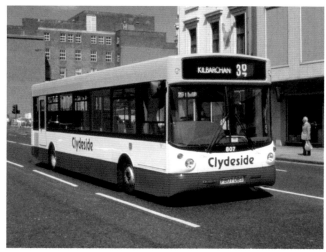

807 P807 DBS was a Dennis Dart SLF/Alexander ALX200 B40F purchased new in 1997, seen in Jamaica Street in Glasgow while bound for Kilbarchan.

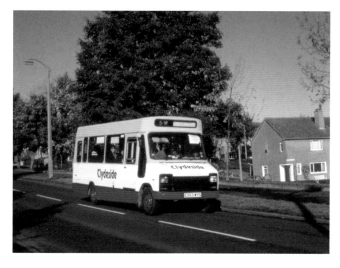

353 E353 WYS was a Renault S56/Alexander B25F purchased new in 1988. Around half a dozen of these buses were refurbished internally to DiPTAC standard and 353 was photographed in Glenburn while bound for Paisley Cross.

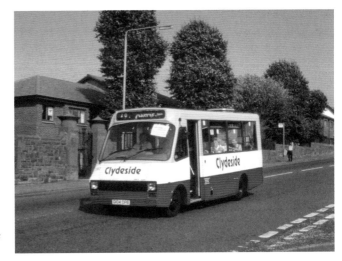

382 G104 DPB was a Northern Counties-bodied Renault S56 acquired from Londonlinks in 1995. It was captured in Johnstone while working on route 20.

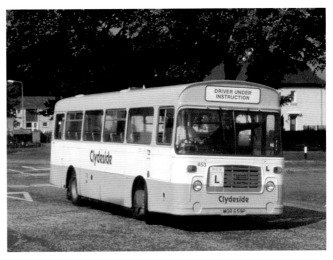

453 MGR 659P was a Bristol LH/ECW purchased from Northumbria as a driver training vehicle and allocated to Inchinnan depot.

140 MIL 9320 (A383 ROU) was a Leyland Tiger/Van Hool Alizee C50Ft seen passing through Greenock on Scottish Citylink service 900 bound for Gourock.

198 H705 UNW was an Optare
Metrorider MR09 B23F purchased
from West Riding in 1997 and
seen in Paisley town centre while
working on service 28 from
Linwood.

801 M927 EYS was a Dennis
Lance/Plaxton Verde B49F
working on service 36 bound for
Kilbarchan.

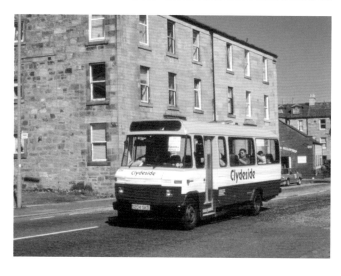

234 D204 SKD was a Mercedes
608D/Reebur DP19F transferred
from Midland Red North in 1995
and shown in Greenock on a local
service.

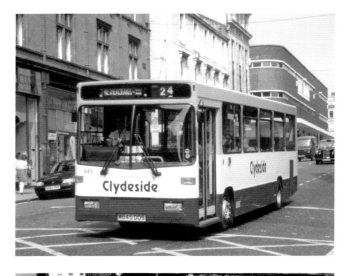

445 M845 DDS was a Volvo B6-50/Alexander Dash B40F caught in Glasgow City Centre while working on service 24 bound for Nethercraigs, which was operated by Inchinnan depot.

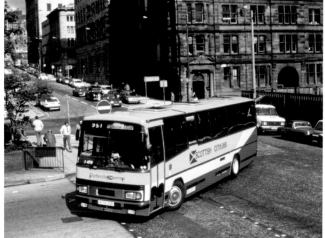

I479 A179 UGB was another Leyland Tiger/Plaxton Paramount Express 3200 C49F in Scottish Citylink livery working on the Glasgow airport service.

PD317/29 D317 SDS/E329 WYS were a pair of Dodge-Renault S56/Alexander AM Type B25F minibuses seen working on Paisley local services, with Paisley town hall in the background. The Skipper branding was only used on the minibus fleet. These little buses were fitted with Perkins engines and Chrysler automatic gearboxes and were quite good to drive.

About the Author

I've often been asked where my interest in buses came from. One theory put forward was that I must have inhaled bus exhaust fumes while still in my pram. This is a non-runner however, as the area in Glasgow I was brought up in was served by electric trolleybuses, so I can only put it down to a rogue gene somewhere. No one else in my family is remotely interested, and as a young child I had toy boats foisted upon me by my doting grandparents. This was no good to me however, as I wanted a fleet of buses, not an armada!

My grandparents, however, started off my bus photography. They would come home from trips abroad but would never finish the film in their camera, so it would be given to me to use the rest of the spool. My first efforts were pathetic because what was visible through the viewfinder was not what came out on the film. As I got older, the results improved by using better cameras.

I left school in 1976 and followed in my family footsteps into the Clydeside shipyards (boats again!), serving my time as a Marine Pipework Engineer. I hated it and got out as soon as I could. I became a 'Clydesider' of a different sort when I went to work at Inchinnan bus garage. I really enjoyed the job and no two days were ever the same. It was an exciting time for the company and everyone was very optimistic about the future.

A succession of owners followed and a lack of investment and commitment to expand saw the company lurch from one crisis to another. Managed decline became the order of the day, and eventually, while under Arriva ownership, I'd had enough. I decided to move to pastures new, but my Clydeside days were very important to me and I can still look back with pride. I started this project with 6,500 colour slides and have chosen some of my favourites, so I hope you enjoy them too.

I would like to thank all the girls in my life: my wife Susan, daughters Sammi and Jenny, and my sister Anne for all their love and support through the years.